LONGWOOD
GARDENS

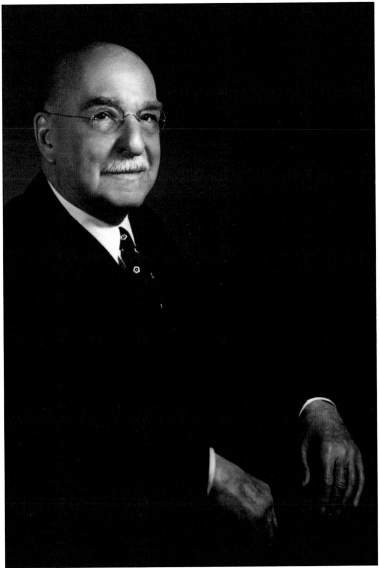

Pierre S. du Pont (1870–1954), one of America's great industrialists, created Longwood Gardens from a historic farm he purchased to save its 100-year-old trees. This portrait was taken by Gottlieb Hampfler just three months before du Pont's death. (Longwood Gardens Archives.)

Front Cover: This image of Longwood's Lower Canal in the Main Fountain Garden was featured in the July 1951 *National Geographic Magazine* with the caption "Longwood's Fountains, Like Geysers or Fireboats in Full Career, Drench the Sky." (John E. Fletcher and Anthony B. Stewart/ National Geographic Creative.)

Upper Back Cover: Tulips along the Flower Garden Walk. (Larry Albee, 2015, LGA.)

Lower Back Cover (from left to right): Roses in June (Bill Rahling, 2011, LGA), thousand-bloom chrysanthemum (Larry Albee, 2012, LGA), fireworks and fountains (Larry Albee, 2009, LGA).

Images of Modern America

LONGWOOD GARDENS

COLVIN RANDALL

ARCADIA
PUBLISHING

Published by Arcadia Publishing
Charleston, South Carolina

Printed in the United States of America

Library of Congress Control Number: 2017935579

For all general information, please contact Arcadia Publishing:
Telephone 843-853-2070
Fax 843-853-0044
E-mail sales@arcadiapublishing.com
For customer service and orders:
Toll-Free 1-888-313-2665

Visit us on the Internet at www.arcadiapublishing.com

*To the hundreds of past, present, and future employees, students,
and volunteers who keep Pierre du Pont's vision alive and growing.*

CONTENTS

ACKNOWLEDGMENTS

In addition to everything else that he did, Pierre du Pont was a history buff. He spearheaded his relatives into collecting everything on the history of the du Pont and allied families before it was lost forever. He was equally interested in the history of the Peirce family, who planted the trees that were the basis for Longwood Gardens. And he saved everything pertaining to his own life and career. Those photographic and manuscript treasures are now at the Hagley Museum and Library in Greenville, Delaware, and allow historians to learn about du Pont and early Longwood Gardens in great detail.

Longwood has continued this tradition by recording its own development since 1954. Documents, blueprints, and books reside in its library and archives. Particularly valuable are hundreds of thousands of images taken by outstanding photographers, especially Gottlieb Hampfler and Larry Albee.

Thanks are due to the archivists and digital managers at both Hagley and Longwood for cataloging and making it possible to reproduce this material. Thanks also to Caitrin Cunningham and the staff at Arcadia Publishing for streamlining the production of this book. It is a new take on a long-cherished cultural treasure that just keeps getting better with age!

The images in this volume (except the front cover) appear courtesy of Hagley Museum and Library (HML) and Longwood Gardens Archives (LGA). Photographers, when known, precede the abbreviation along with the year.

For complete information on Longwood Gardens, visit www.longwoodgardens.org.

INTRODUCTION

Few gardens in America, or elsewhere in the world, have achieved the level of enthusiasm and affection showered upon Longwood Gardens near Kennett Square, Pennsylvania, in the historic Brandywine Valley some 30 miles west of Philadelphia. The property has been inhabited for thousands of years and developed for aesthetic enlightenment for more than two centuries, but public acclaim has come only during the past 100 years, with a total visitation exceeding 50 million guests.

What has made Longwood so successful? Magnificent old trees are certainly the foundation, combined with a unique sense of theater and year-round beauty that are difficult to imagine in a northern clime where cold weather prompts the landscape to slumber for several months. Yet here an eye-opening spectacle can be found every day.

Many generations helped create Longwood, but one individual—Pierre Samuel du Pont, an industrialist, conservationist, farmer, gardener, engineer, impresario, and philanthropist—made the most enduring contribution. His achievements include flowered landscapes where all the elements merge into a wonderfully satisfying environment, indoor gardens that celebrate the plant kingdom no matter what the weather outside, magnificent fountains that recall the splendors of Europe, and a level of horticultural excellence that can hold its own against any the world has to offer.

The easiest way to comprehend Longwood's history is to divide it into various periods of management. For centuries, Native Americans lived on the land. Subsequent European-influenced generations made it what it is today. The twin grandsons of the settler who first farmed the land brought a love of nature and the desire to study natural history and arboriculture. They planted the trees that established the property as one of America's first and finest arboretums. One descendant continued its development and invited the community to enjoy the beauty.

Pierre du Pont (1870–1954) bought the farm in 1906, but he was not trained as a farmer. From a prominent Delaware industrial family that had arrived from France in 1800, du Pont was imbued with his family's love of gardening. He received a degree in chemistry from the Massachusetts Institute of Technology in 1890. A decade later, he was a rising industrialist about to take the DuPont chemical company, and subsequently General Motors, to the top of the business world. Historians credit him with being the father of the modern corporate structure, and his fabulously successful career occupied most of his time.

But du Pont was also keenly aware of the beauty of nature, especially trees, and he bought the Longwood property to save its 100-year-old specimens. His contributions can be broken into two periods. For the first two decades, he was involved in almost every detail, personally designing gardens, choosing plants, and handling the fine points of engineering. By the 1930s, he had turned over the operation to a trusted staff of managers who had been hired years before, many for their first job. Some had attended college, some not, but they all learned by his example. For the last two decades of his life, du Pont paid the bills and let his staff make routine decisions. But most importantly, he set up the financial structure to endow Longwood and assure its continuation, something creators of great gardens rarely have the vision or assets to do.

Du Pont died in 1954, and the first professional director was hired the following year. Russell Seibert set the course for transforming a private estate into a privately owned but increasingly public garden. He established programs and philosophies that continue to this day. His successor, Everitt Miller, brought food service and a greater awareness of public enjoyment. Fred Roberts, the third director, was especially interested in infrastructure and physical plant maintenance, frequently overlooked but crucial to keep aging cultural properties alive. Paul Redman, who assumed the top position in 2006, has focused on short- and long-term planning and has insisted on the latest technology and marketing to encourage instant communication with increasingly savvy visitors. The results have been spectacular, with over one million guests a year from around the world, a total that has been increasing every year.

Noteworthy achievements include preservation—of the original Quaker tree plantings, of Pierre du Pont's conservatories and fountains, and of the latest creations; horticulture—ravishing displays chosen for aesthetic rather than botanical interest, with nearly 11,000 different types of plants from more than 200 plant families; innovation—improving the gardens with often unseen but cutting-edge technology to control climate and fountains, to sell tickets, and to reach visitors; performing arts—more than 12,000 music, dance, and theater events in an unparalleled setting, plus 3,000 illuminated fountain displays and 150 fireworks displays since 1931; education and training—for thousands of professionals and hundreds of thousands of amateurs; philanthropy—Pierre du Pont's legacy has distributed the equivalent of $3 billion to Longwood, southeastern Pennsylvania, and the state of Delaware; and last but not least, hospitality—more than 50 million guests have enjoyed Longwood Gardens. With ever-increasing yearly attendance, it is likely that 150 to 200 million more will visit over the next century.

As Longwood has evolved, one can discern a sophisticated management structure. Branding, marketing, short- and long-term planning, programming, preventive maintenance, information technology, key performance indicators, professional development, and environmental stewardship are all concepts from the business and academic worlds that are now beneficial to a horticultural property.

Improvements under way or in the planning stage include state-of-the-art facilities, sharing of information and expertise, staff exchanges, and training programs that reach from kindergarten to post-graduate fellowships. The goals are far reaching, and there is every reason to believe they will be attained, often ahead of schedule.

The author, named the first P.S. du Pont Fellow in 2008, has had the unique experience of working with Longwood's staff since a student in 1973 and as an employee since 1977. He has studied thousands of original documents, blueprints, and photographs over the past 40 years and has interviewed many of those who actually built Longwood. It is a singular perspective upon which the highest level of accuracy is attempted. What is remarkable about this publication is the use of old color photographs, many of which have only recently been rediscovered and most of which have never been published before.

One

PLANTING A
HISTORIC ARBORETUM
1700–1905

Longwood's unique story encompasses more than 300 years. For generations, the region had been inhabited by the Lenni Lenape, Native Americans who fished and foraged, constructed dams, raised corn, and hunted venison, bear, and elk. Quartz spear points dating back to 2000 BC have been found.

In 1700, George Peirce, a Quaker who had emigrated from England in 1684, purchased 402 acres of this English-claimed land from William Penn's commissioners. Half the acreage was presented to his daughter in 1703. On the remaining acreage, his son Joshua established a farm in 1709, building a log cabin and clearing the land. In 1730, Joshua constructed the brick farmhouse that, enlarged, still stands today.

In 1798, in keeping with the Quaker attitude toward the study of natural history, Joshua's 32-year-old twin grandsons Joshua and Samuel began planting an arboretum that eventually covered 15 acres. It was known within 50 years as one of the finest collections of trees in the nation. Its most conspicuous feature was a conifer collection laid out in parallel avenues. There were also deciduous trees from Europe, Asia, and North America. Native species were collected from the wild. Samuel dug small trees and shrubs locally. Joshua traveled as far north as the Catskill Mountains and south to Maryland's cypress swamps, returning with plants in his saddlebags. Other trees were acquired through plant exchanges with fellow horticulturists.

Samuel died in 1838 and Joshua in 1851, and the farm was inherited by Joshua's son George Washington Peirce. He added to the collection and developed the arboretum into a pleasure ground. Boating parties and picnics were frequent neighborhood occasions. When George Peirce died in 1880, the park was in its prime, both as an arboretum and as a pleasure garden.

Peirce's heirs showed little interest in horticulture and allowed the park to deteriorate. Finally, in 1905, the Peirce family sold the farm. It was resold twice in the next 14 months. The third buyer made arrangements for the trees to be cut, which prompted 36-year-old Pierre du Pont to purchase the farm in 1906, giving birth to Longwood Gardens.

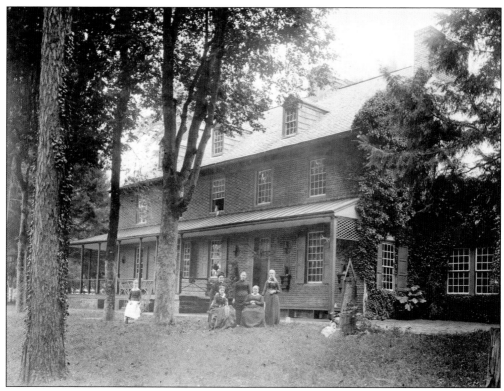

Members of the Stebbins and Woodward families, who were Peirce descendants, posed for this c. 1884 photograph on the south side of the Peirce House. In 1880, upon the death of George Washington Peirce, the property was inherited by the five children of his sister Mary Peirce Stebbins, one of whom had married a Woodward. In 1905, Mary's daughter-in-law sold the property out of the family. (HML.)

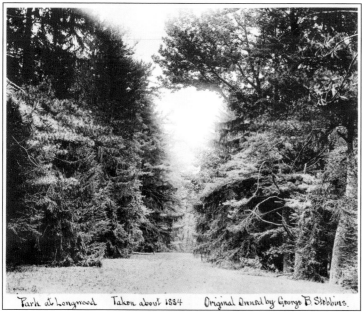

Park at Longwood Taken about 1884 Original Owned by George B. Stebbins.

The vista looking east from the Peirce House in 1884 revealed a double avenue of massive conifers and deciduous trees. Peirce's Park, or Evergreen Glade as it was sometimes called, had been so heavily planted that some trees died from overcrowding. The tree park and surrounding lawns and lakes hosted informal community social events in the second half of the 19th century. (HML.)

Another view of the same vista also dates from 1884. Forty years earlier, Dr. William Darlington, a well-known local physician, noted that the Peirce brothers "by their splendid collection of Evergreens and other kindred embellishments, have made their farm one of the most delightful rural residences within this commonwealth." (HML.)

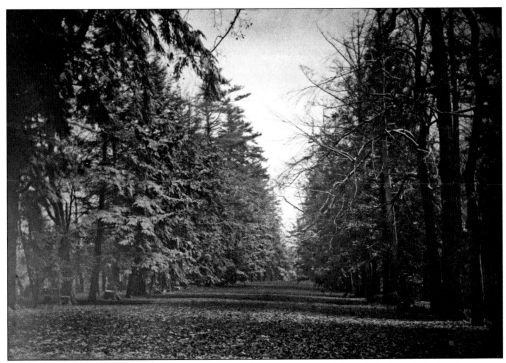

This c. 1915 color photograph reveals almost the same view, although in late fall the deciduous trees are mostly bare. Many American chestnut trees had been lost in 1912 due to chestnut blight, which undoubtedly affected the thickness of the surrounding woods for some years. (HML.)

Peirce's Park runs along an elevated west-to-east ridge. This c. 1915 photograph shows the view from the south looking north across the Large Lake. Hemlocks, pines, and spruces were plentiful. The Peirce House is several hundred feet out of view to the left, along a high point of the ridge. (HML.)

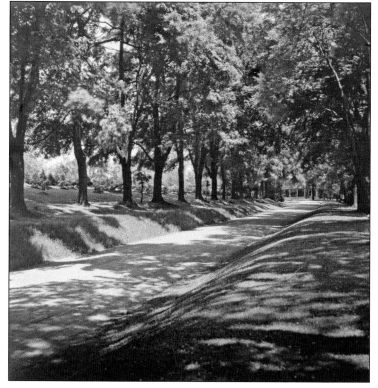

The entrance lane to the Peirce farm was bordered by an avenue of mostly sugar maples that created a high-limbed green vault, like a cathedral of trees. By the time this photograph was taken about 1912, the lane was more manicured than it would have been in the 19th century. In the distance is the Peirce House. (HML.)

This 1916 view looking southeast, with the Peirce House at left, shows how the many trees and shrubs planted in the 19th century gave a forested feeling close to the house and blocked views toward the south. In the distance is a magnolia in bloom. (HML.)

This c. 1919 view over the first du Pont flower gardens shows how heavily planted the grounds were around the house, in the distance to the right. Most of the trees originated with the Peirces. Today, many of these trees and most of the shrubs are gone, revealing much more of the house and opening splendid vistas. (HML.)

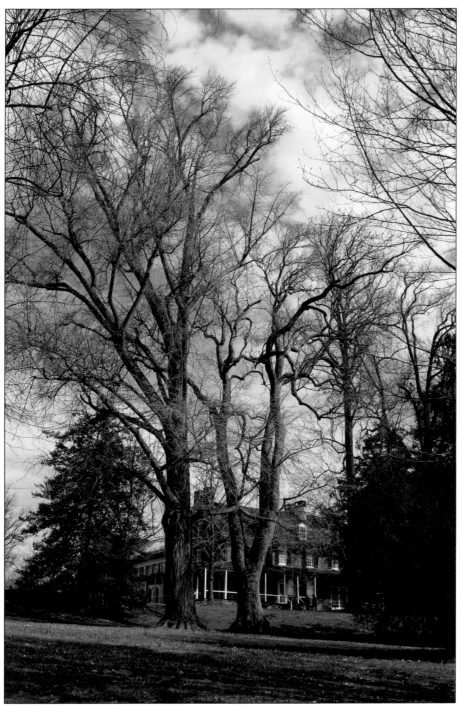

Two of the most revered trees from the Peirce era are a giant *Ginkgo biloba* (left) and *Magnolia acuminata* var. *subcordata* 'Peirce's Park' (right), which is the tallest such tree in the country. They were planted 10 feet apart around 1798, so this March 2017 photograph marks their probable 219th birthday at this location. The ginkgo is at least 112 feet tall, the magnolia at least 84 feet tall. (Colvin Randall, 2017, LGA.)

Two

BUILDING LONGWOOD

1906–1954

Pierre du Pont bought the 202-acre Longwood farm in 1906 to save its trees and make it a place where he could entertain. He subsequently designed most of what is enjoyed today.

In 1907, du Pont laid out the 600-foot-long Flower Garden Walk with a round pool spouting Longwood's first fountain. The next year, several small, enclosed gardens were created nearby. Although later efforts would draw on Italian and French forms, these early designs reflected an old-fashioned influence. From this simple axial layout Longwood Gardens grew, albeit in piecemeal fashion as the mood touched its creator.

The expansion that followed reflected du Pont's increasing resources as well as the unbridled enthusiasm of the times. Annual garden parties would often unveil a new feature, especially the Open Air Theatre in 1914. A glassed atrium was added to the expanded farmhouse that same year. Du Pont married Alice Belin in 1915, and with her encouragement, the projects continued. The huge Conservatory opened in 1921. The public suddenly came in droves, and Longwood quickly became one of the world's great gardens.

This was followed by an epic increase in fountain construction, with the Italian Water Garden and expanded Open Air Theatre finished in 1927 and the monumental Main Fountain Garden debuting in 1931. Longwood now had more fountains than any other garden in the Western Hemisphere.

Additions included the Azalea House in 1928, the Ballroom and Aeolian organ in 1930, and an unusual analemmatic sundial in the mid-1930s. Twenty-five surrounding properties had been purchased as opportunity arose, and by 1935, Longwood had grown to 926 acres. The gardens weathered the Depression with no ill effects, and du Pont's vision was complete, except for a horticultural school. But now 65-year-old Pierre du Pont had to figure out what to do with this amazing cultural resource. In 1937, he created the Longwood Foundation to handle his charitable giving. In 1946, the government gave approval for the foundation to operate the gardens "for the sole use of the public for purposes of exhibition, instruction, education, and enjoyment." When du Pont died in 1954, the future of Longwood was assured.

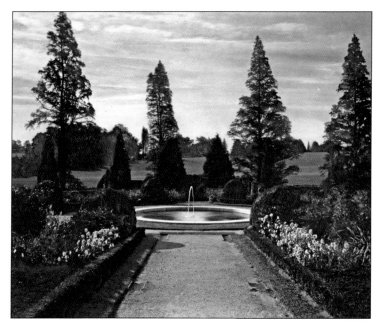

This c. 1922 hand-colored photograph shows the Flower Garden Walk looking south. Pierre du Pont designed this in 1907. The 20-foot-diameter pool contains Longwood's first fountain, originally fed by gravity from a tank in the attic of the Peirce House. The tall trees are *Taxodium*, or bald cypress, planted by the Peirces. The distant hill was scooped out to become the Visitor Center parking lot in 1962. (HML.)

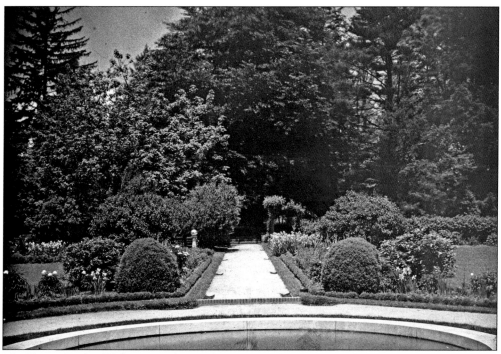

The Flower Garden Walk, pictured around 1915, extends north toward a magnificent copper beech planted by the Peirces. The tree was destroyed during Hurricane Hazel in 1954. Its replacement was equally majestic but had to be removed in 2011 due to disease. A third beech is now growing here. To the left of the path, a shiny mirrored gazing ball reflects the sun. (HML.)

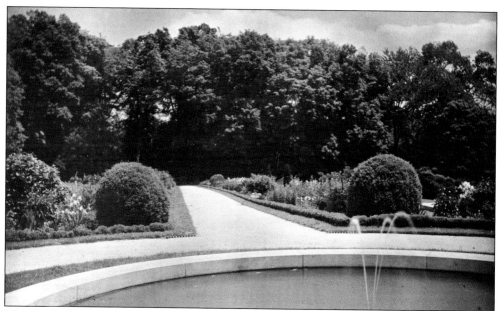

This c. 1915 view of the Flower Garden Walk looks east toward the Peirce woods, where sugar maples were tapped for syrup. The 600-foot-long walk was unpaved and was edged with small boxwood, with much larger specimens gracing the main intersections. At the end of the path, out of sight in this photograph, is a circular "whispering bench," whose concave shape permits sitters at either end to whisper to each other. (HML.)

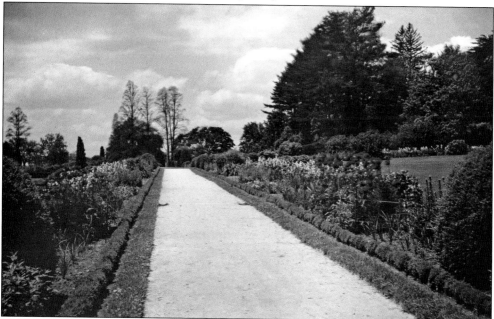

Looking west along the Flower Garden Walk around 1915 shows the unusual length of the garden, originally with a white gravel walk bordered by low boxwood edging. Red poppies and blue iris are typical of the flowers Pierre du Pont preferred, with maximum bloom in the spring. In the distance, tall bald cypress trees mark the western terminus of the walk at the Open Air Theatre. (HML.)

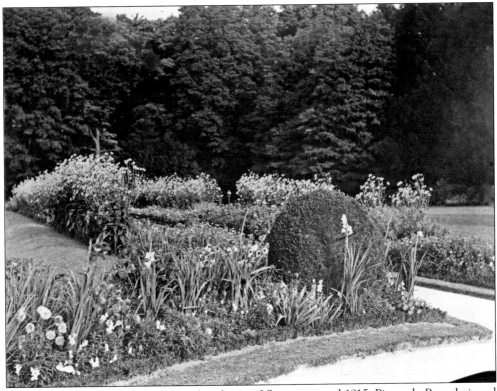

The Flower Garden Walk shows an abundance of flowers around 1915. Pierre du Pont designed the planting plans for his early gardens himself, dividing the growing season into four periods of bloom. June's flowers inspired du Pont to host a garden party for several hundred family, friends, and business acquaintances. These annual events became a highlight of the summer social season in nearby Wilmington, Delaware, and Philadelphia. (HML.)

The Peacock Arbor was erected in 1916 and was covered with pink climbing roses, which bloomed profusely in June. It was near the eastern end of the Flower Garden Walk, extending to the south. The fanciful name came from a peacock ornament on top. The arbor was dismantled and put into storage several years after Pierre du Pont's death. (William Spruance, 1923, HML.)

Three gardens designed in 1908 below the Flower Garden Walk are accessed by this stairway, shown here around 1915. The middle of the three has this square pool that served as a reflecting pond when viewed from above from a now-vanished tool shed. Years later, a jet was added, and it became the Square Fountain. The antique oil jar came from Florence, Italy, in 1913. (HML.)

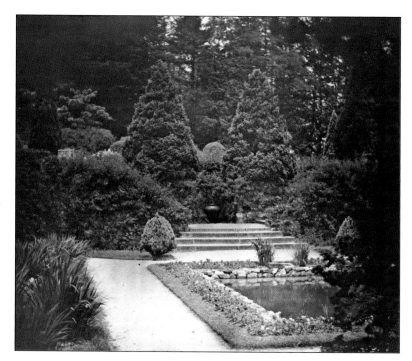

Bessie Cazenove du Pont and John Darby performed at the June 1916 garden party. The newspaper noted, "The main fairy, impersonated by Miss Bessie du Pont, who looked a real 'Titania' in her white and silver ballet dress, danced for the favored mortal . . . and afterward, in lavender silk, yellow scarf and bobbing curls, danced a beautiful Empire waltz with him." (HML.)

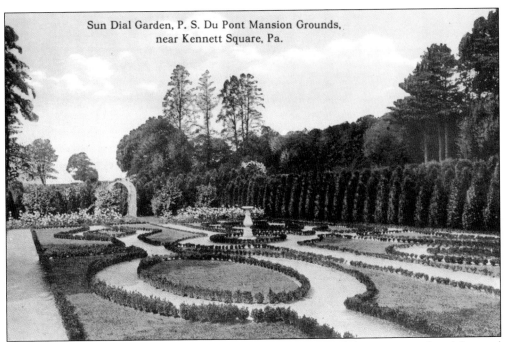

Sun Dial Garden, P. S. Du Pont Mansion Grounds, near Kennett Square, Pa.

The 1908 Sundial Garden, shown here around 1916, was west of the square pool and featured a parterre of 2,250 dwarf boxwood and a small sundial. Pierre du Pont sometimes called it the Curlicue Garden. For many years it was erroneously called the Maze Garden, although there was no possibility of getting lost in it. In 1976, it was replaced by the Peony Garden, designed by Thomas Church. (HML.)

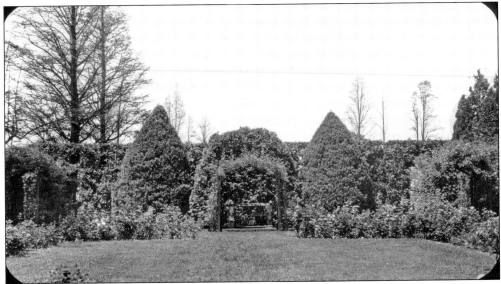

East of the Square Fountain was the 1908 Rose Garden, shown here in 1922. It featured 186 roses in 31 varieties in two long beds. Six cedar arbors covered with climbing roses sheltered two benches. In the 1950s, it was replanted with peonies, and in 1976, it was transformed into the Wisteria Garden, designed by Thomas Church. (William Spruance, 1922, HML.)

20

Pierre and Alice du Pont loved roses. This c. 1922 photograph shows how roses were trained to enclose green passageways defined by clipped arborvitae. The double row of hedges created a tunnel effect. Today, there are just single rows of hedges marking the outer limits of the small compartment gardens. (HML.)

The 600-foot-long Flower Garden Drive parallels the Flower Garden Walk. In this c. 1922 photograph, a long arborvitae tunnel is topped with pink roses. The tall bald cypress tree on the left is in a row planted by the Peirces. Pierre du Pont filled in the gaps and then planted the right side of the drive in 1947 with similar trees to form a magnificent allée. (HML.)

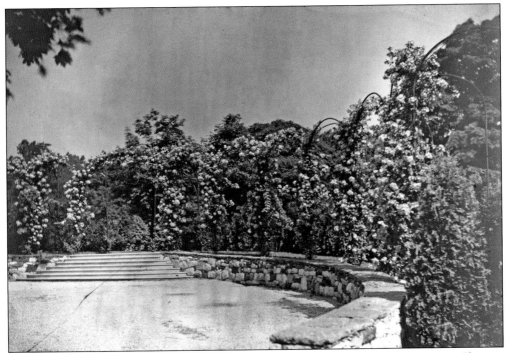

'American Pillar' roses have always grown up this arched arbor just south of the Open Air Theatre. They bloom in June to great effect. The arbor was constructed by du Pont in 1916 as a semicircle and is shown here a few years later. In 1962, a similar curve was added to the south to complete the circle. In the center now is an old Italian wellhead given to Longwood in 1970. (HML.)

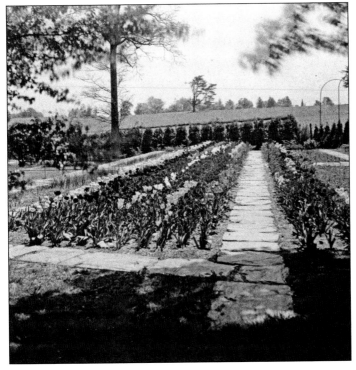

The Terrace Garden at the west end of the Flower Garden Walk was planted with mostly tulips, as seen in this c. 1916 photograph, although by 1922, roses dominated. Du Pont designed this three-level garden as the last segment of the original flower gardens, along with the adjacent Rose Arbor. (HML.)

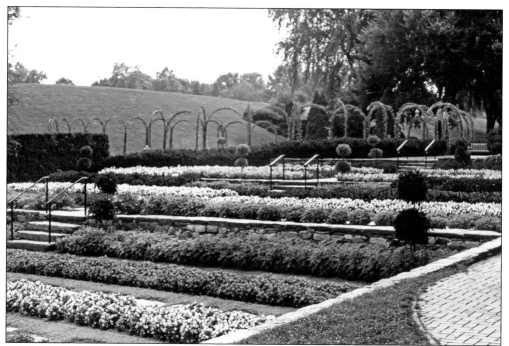

By 1973, when this photograph was taken, the Terrace Garden began the growing season with tulips, followed by summer annuals such as begonias and coleus, and ended with a spectacular display of fall chrysanthemums. It was redesigned by Thomas Church and reopened as the Theatre Garden in 1975. (Gottlieb Hampfler, 1973, LGA.)

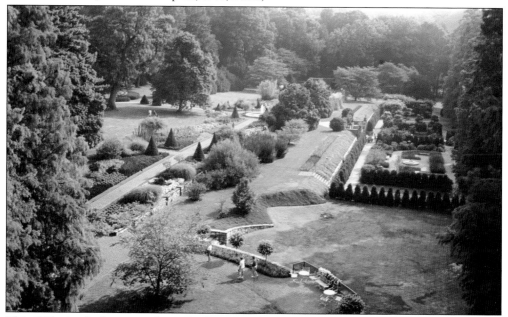

This 1991 view looking east shows the flower gardens some 80 years after their construction. The 1907 Flower Garden Walk was paved with brick in the 1930s and the boxwood edging eventually replaced by yew and then turf. The lower gardens at right retain their 1908 dimensions but have been completely transformed into wisteria and peony gardens. (Larry Albee, 1991, LGA.)

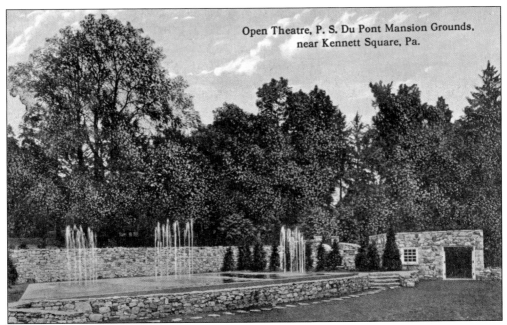

Longwood's Open Air Theatre was constructed in 1913 and first used for a garden party entertainment in 1914. It was modeled on the Villa Gori in Siena, Italy, which Pierre du Pont visited in 1913. In 1915, he added five rings of fountain jets on the main stage, activated by foot pedals in the grass in front of the stage. These were inspired by trick fountains found in Italian gardens. (1916, LGA.)

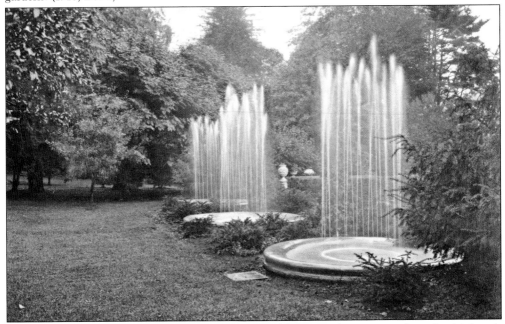

At the back of the stage on the upper level, three marble basins also contained jets. In this hand-colored 1922 photograph, the marble is shown as blue, whereas it was likely a natural color. These upper fountains were occasionally lit for special entertainments, so they were the first illuminated jets at Longwood. (HML.)

This 1922 hand-colored photograph shows the Open Air Theatre stage from the wings, which were hemlocks shaped into rectangular hedges. In the 1930s, arborvitae replaced the hemlock and still grows there today. On at least one occasion, a danseur missed the narrow exit, ramming his elevated ballerina head first into the shrubbery! (HML.)

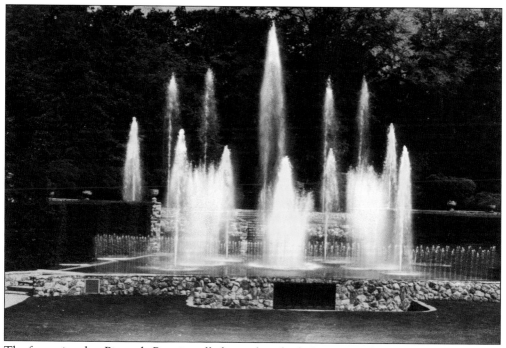

The fountains that Pierre du Pont installed into the rebuilt Open Air Theatre in 1926–1927 have 750 jets illuminated by 600 lights, most of which are hidden below removable covers. After a show, these are flipped open by hand and the fountains glisten like rainbows. At the end, compressed air rockets the water 50 feet into the treetops. This 1928 photograph is hand colored. (HML.)

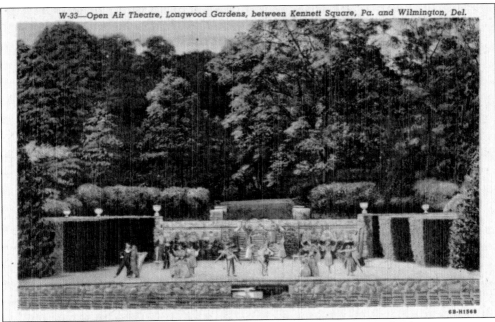

On June 15, 1928, New York impresario John Murray Anderson presented a four-part evening garden party entertainment in the renovated Open Air Theatre. The last part was entitled *Carnival* and featured nine dances, such as a "Veil Dance," "Bacchanale," and "Dancing Tambourines." Here is the finale in rehearsal that afternoon. (F.E. Geisler, 1928, LGA.)

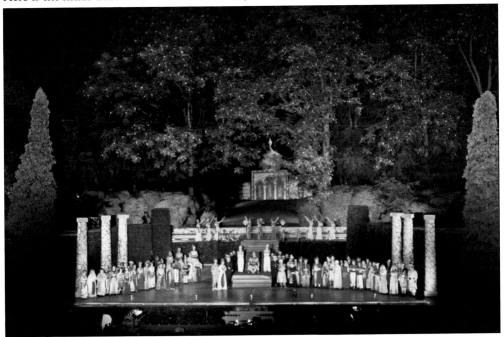

A local Wilmington, Delaware, troupe named The Brandywiners coalesced in 1932 to present a musical at Longwood. They have returned every year (except during World War II) and have presented more than 500 performances of more than 80 shows. Here, they perform *Kismet* in 1957. (Gottlieb Hampfler, 1957, LGA.)

From 1926 to 1927, Pierre du Pont excavated under the original stage to create spacious underground dressing rooms for the performers. The soil was used to slope the auditorium lawn for improved audience visibility. He also built elaborate illuminated fountains into the stage. Shown here are the Savoy Company performers in 1957 preparing for *The Pirates of Penzance*. (Gottlieb Hampfler, 1957, LGA.)

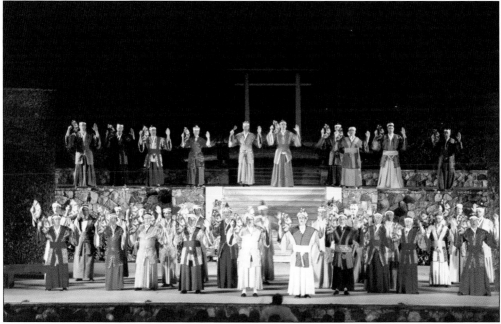

The Savoy Company from Philadelphia was the first theatrical group to perform in the Open Air Theatre in June 1916 with a Gilbert & Sullivan operetta. They returned in 1923 and have brought more than 90 productions and 150 performances to Longwood's stage. Here is their 2003 show, *The Mikado*. (Larry Albee, 2003, LGA.)

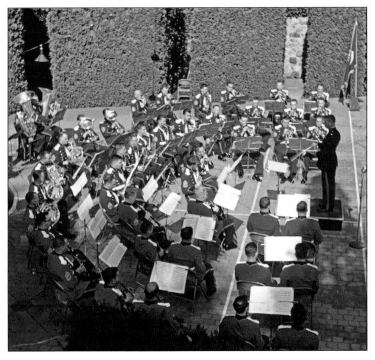

This 1957 Marine Band concert recalls the celebrated performances at Longwood by John Philip Sousa, former conductor of the Marine Band. Sousa's own 70-piece band performed afternoon and evening concerts annually from 1922 to 1926 and in 1928 and 1930, totaling 14 performances. However, only the 1928 evening performance was held in the theater, for fear of rain; all others were held in the Conservatory. (Gottlieb Hampfler, 1957, LGA.)

Across the front of Longwood's stage is a 10-foot-high water curtain, shown here in 1958. Rear lighting creates an opaque screen, hiding the performers from spectators. Once the curtain comes down, footlights on the other side of the water trough illuminate the actors on stage. At the end, sparkling water raises the curtain and is followed by a full-stage fountain display. (Gottlieb Hampfler, 1958, LGA.)

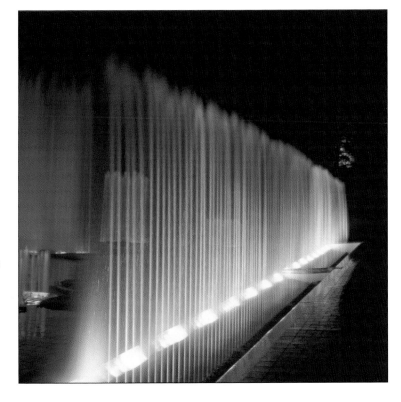

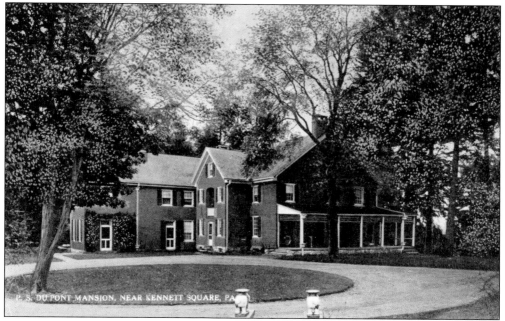

In 1909, Pierre du Pont modernized the old Peirce House (today called the Peirce-du Pont House) with a two-story service addition shown to the left of the original building in this 1912 postcard. He also added central heating, plumbing, and electricity to the entire house. (HML.)

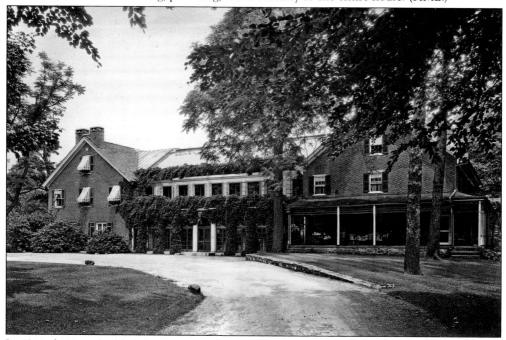

In 1914, du Pont doubled the size of his house with an extension (left) that mimicked the bulk of the Peirce construction (right) and connected the two with Longwood's first conservatory. The Wilmington, Delaware, firm of Brown & Whiteside designed the addition, which was an architectural success—the two parts merge seamlessly. This hand-tinted photograph dates from 1928. (HML.)

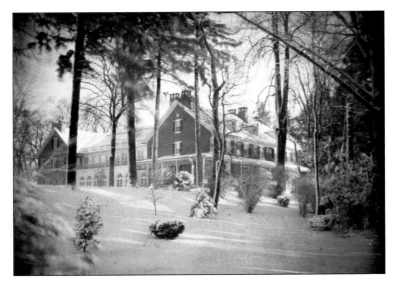

This c. 1919 view of the Peirce-du Pont House from the southwest shows the simple but elegant composition surrounded by mature trees. By comparison with some of the du Pont family's other mansions, it is almost rustic. The glass-enclosed atrium is always delightful on a snowy day. (HML.)

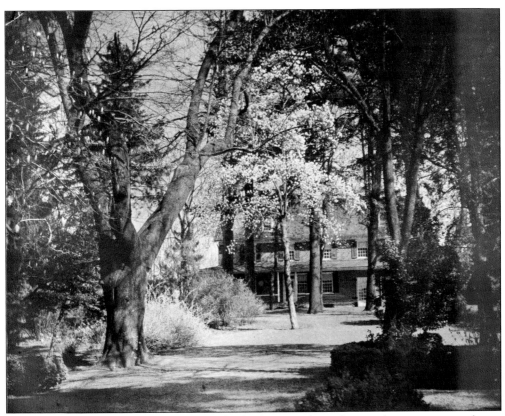

This c. 1918 springtime view from the garden looking north emphasizes the importance of trees surrounding the house. Yellow forsythia and white magnolias are in bloom. A 1916 survey map shows dozens of trees and shrubs in close proximity to the house. Had these mature plantings not existed, Pierre du Pont probably would not have purchased the property. (HML.)

This c. 1915 view inside the house conservatory looking toward the 1914 addition shows calla lilies in bloom and luxurious plantings, including vines, already making their way up the arched openings. The arch is an architectural motif that appears repeatedly in later Longwood construction. The windows are designed to lower on chains into the basement in summer, with screens pulled up to replace the glass. (HML.)

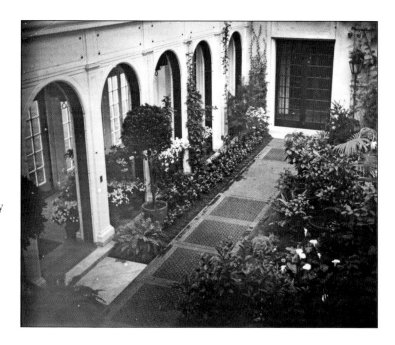

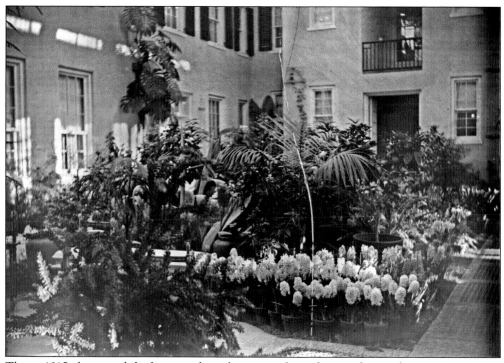

This c. 1915 photograph looking south in the atrium shows fragrant hyacinths sitting in pots on the center plot. Usually pots were buried or removed so as to be invisible; perhaps installation was still under way. The house and atrium opened to the public in 1976 and can be visited every day. About two-thirds of the ground floor is now a museum; the remainder and upper floors house staff offices. (HML.)

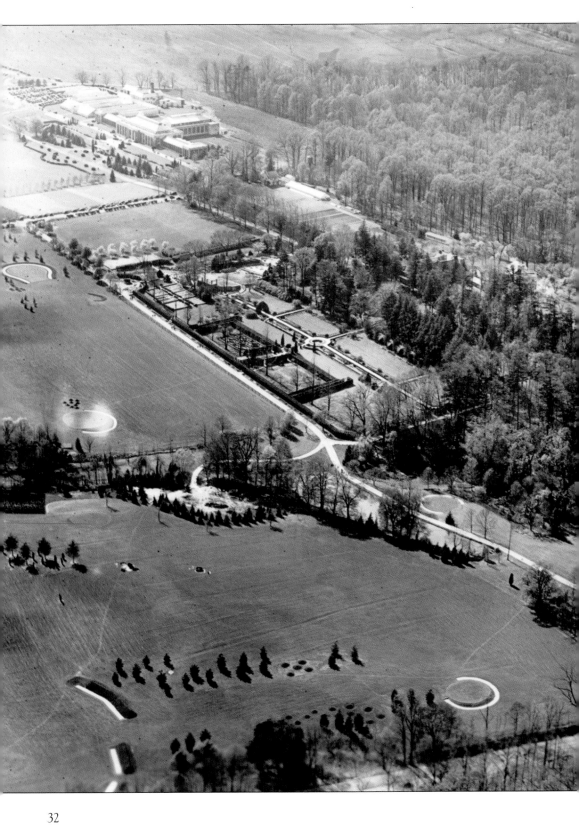

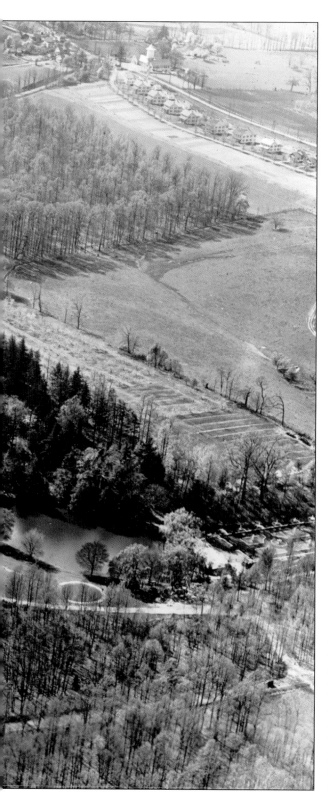

This 1927 aerial photograph shows much of the Longwood property at that time. At the upper left is the Conservatory. The rectangle with parked cars, to the right of the nine-hole golf course, is the Cow Lot, with a tennis court in the bottom corner. The flower gardens stretch diagonally to the right: Rose Arbor and Terrace Garden, Open Air Theatre (under enlargement), Flower Garden Walk, Sundial Garden, Square Fountain, and Rose Garden. The Peirce-du Pont House is hidden in the darker trees of Peirce's Park, with two lakes toward the bottom of the image. The Italian Water Garden sits at lower right. At upper right is a row of tenant houses. Out of view are the estate's farm lands. (HML.)

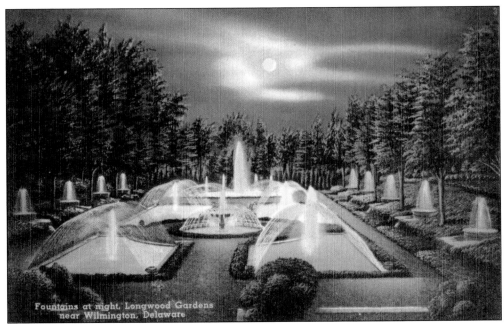

The Water Garden, renamed the Italian Water Garden after Pierre du Pont's death, was inspired by the Villa Gamberaia outside Florence, Italy, and built from 1925 to 1927 to du Pont's design. This fanciful 1930s postcard shows it illuminated under a full moon, although it never was. Only in recent years has it been lit on special occasions. (LGA.)

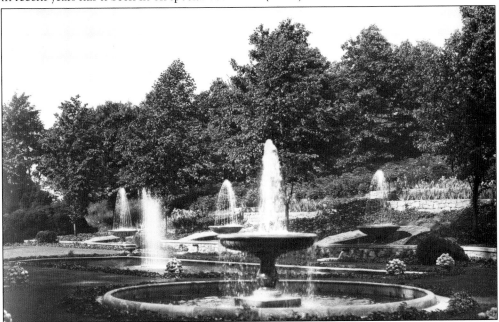

The Italian Water Garden has 12 blue-tiled pools with cream-colored limestone copings and carved ornaments. The green grass, ivy borders, and clipped linden trees create a peaceful landscape enlivened by 600 jets of sparkling water. Du Pont did all the hydraulic calculations himself, which proved accurate when the garden was rebuilt in 1991–1992. This view dates from 1928 and shows iris blooming on the hillside. (HML.)

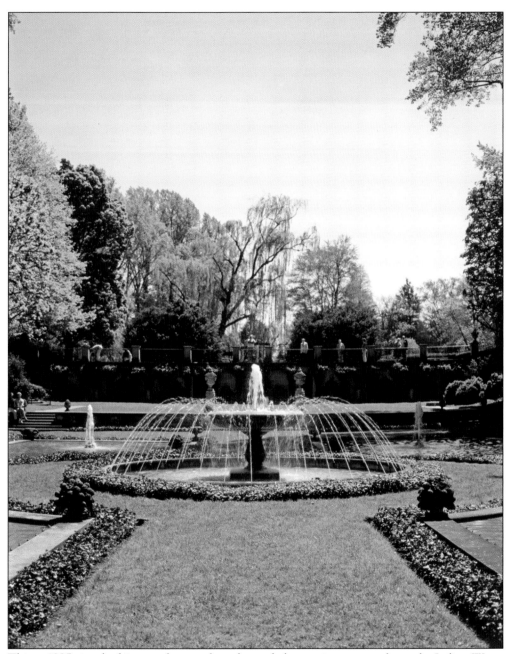

This c. 1985 view looking south toward an elevated observation terrace shows the Italian Water Garden. Along the far wall, hidden by shadows, ivy-covered arches are embellished with overflowing terra-cotta jars and dripping limestone ornaments. At far right in the distance is a curved stone staircase down which water cascades. The garden has 12 separate water effects, including one that supplies three waterfalls. (Larry Albee, c. 1985, LGA.)

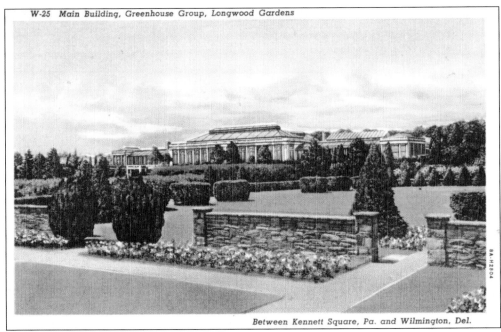

Between Kennett Square, Pa. and Wilmington, Del.

The Conservatory rises majestically on a ridge that runs west to east to the Peirce-du Pont House and beyond through Peirce's Park. The complex was constructed from 1919 to 1921, with many subsequent additions. Three designers (Ferruccio Vitale, Alexander Harper, and J. Walter Cope) consecutively worked on the project, but Pierre du Pont was so involved that his input dominated. This postcard dates from the 1930s. (LGA.)

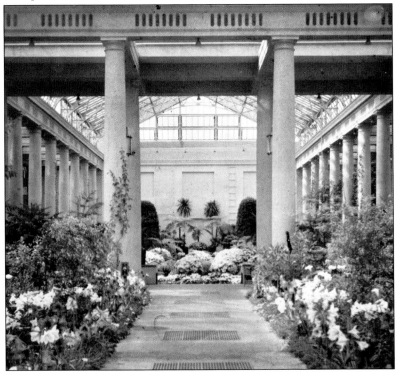

This is one of the oldest color photographs of the Conservatory interior, taken probably in early 1922. The central walk of the Orangery leads to the Exhibition Hall. The two spaces form a T, 181 feet wide by 204 feet deep, with a 25-foot-tall colonnade around the interior edge. The ridge of the central roof rises about 40 feet. (HML.)

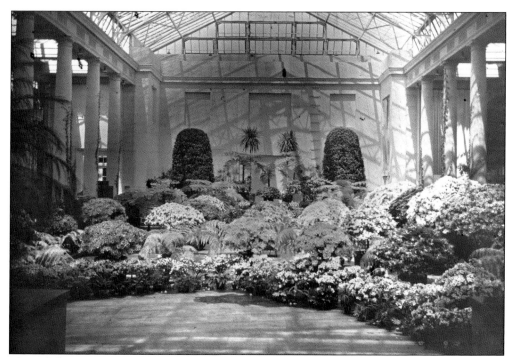

The Exhibition Hall was filled with azaleas and rhododendrons for an early spring display in 1922. The space serves as an auditorium for both plants and performing arts events. Between the far left pair of columns can be seen the back of the Aeolian pipe organ console, which played 3,650 pipes in a chamber at the far right, before there was the Ballroom. (HML.)

This May 15, 1924, photograph shows the Exhibition Hall after the Music Room was added in 1923, adjoining the far north wall, but before interior curtains were hung. Designed by J. Walter Cope, the Music Room was used for entertaining by the du Ponts. The organ console was relocated to the Music Room, but the public could still hear the concerts from the Conservatory. (William Spruance, 1924, HML.)

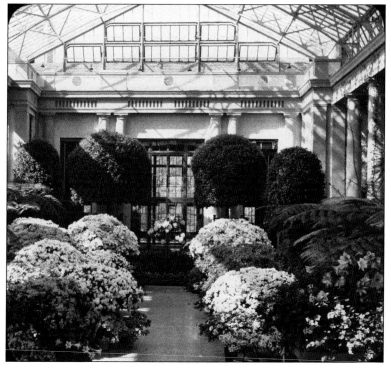

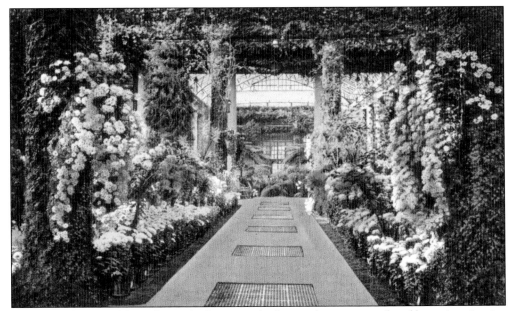

This fanciful postcard from the 1930s shows mostly chrysanthemums as colored by an imaginative artist. Mums have been a fall feature at Longwood since the Conservatory opened, and they have been trained in a wide variety of styles, especially as cascades hugging the columns as shown here. Today's Chrysanthemum Festival features an even greater number of forms. (LGA.)

This 1920 photograph shows the holding greenhouse where azaleas and rhododendrons were stored. This was the first greenhouse in the complex to be finished because the tender azaleas would not survive outdoors. They would then be displayed on the Exhibition Hall floor. Today, this greenhouse has been transformed into the Mediterranean Garden. (HML.)

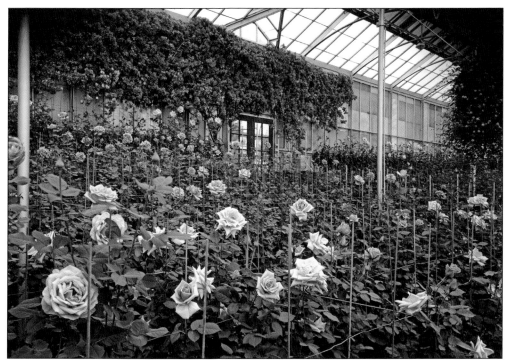

The Rose House is a long greenhouse with stepped beds facing south for maximum sunlight, allowing du Pont's gardeners to have roses in bloom during the winter months. This photograph was taken in 1947. (Gottscho-Schleisner, 1947, LGA.)

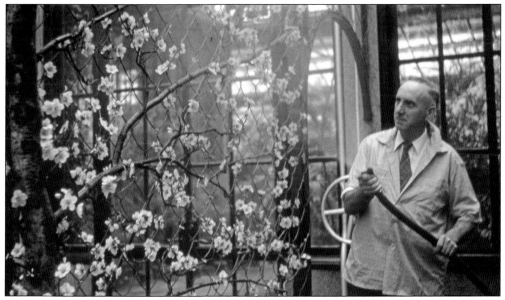

Many of the greenhouses were devoted to fruit and vegetable production. Crops included cauliflower, celery, lettuce, tomatoes, melons, bananas, pineapples, and figs. At least 14 varieties of grapes were grown. Apricots, nectarines, and peaches were favorites, trained here in 1958 as espaliers against wire frames. The flowers are pollinated by mist since the greenhouses are usually free of insects. (Gottlieb Hampfler, 1958, LGA.)

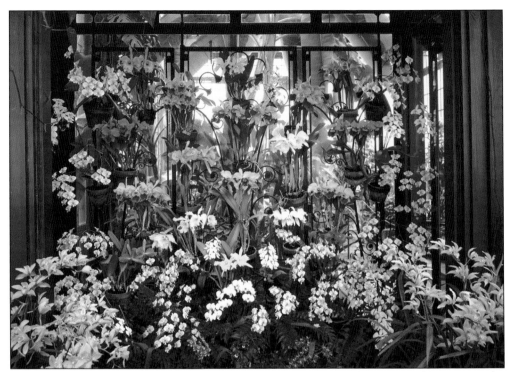

The du Ponts were passionate orchid collectors and had one of the finest collections in the country. Alice du Pont was on the board of the American Orchid Society for many years. This 1947 photograph shows about one-sixth of the display in this room alone. Today, there are 7,500 plants in five additional non-public growing houses to supply year-round bloom. (Gottscho-Schleisner, 1947, LGA.)

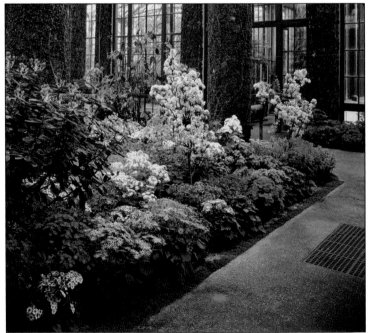

Late winter in 1947 in the Orangery excited the senses with a plethora of flowering crabapples and a rainbow of cinerarias. During World War II, the Conservatory displays were scaled back, so in the postwar environment, a return to exuberant displays was a cause for celebration. (Gottscho-Schleisner, 1947, LGA.)

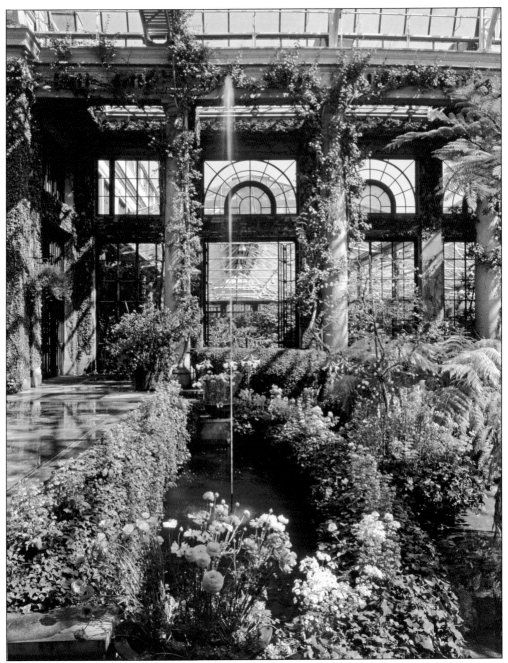

This 1947 view shows the north end of the Exhibition Hall, with a fountained pool that can also serve as an orchestra pit adjoining the marble stage at left. John Philip Sousa and his band performed in this location for 13 of the 14 concerts he gave at Longwood. This view looks east into the old Azalea House. (Gottscho-Schleisner, 1947, LGA.)

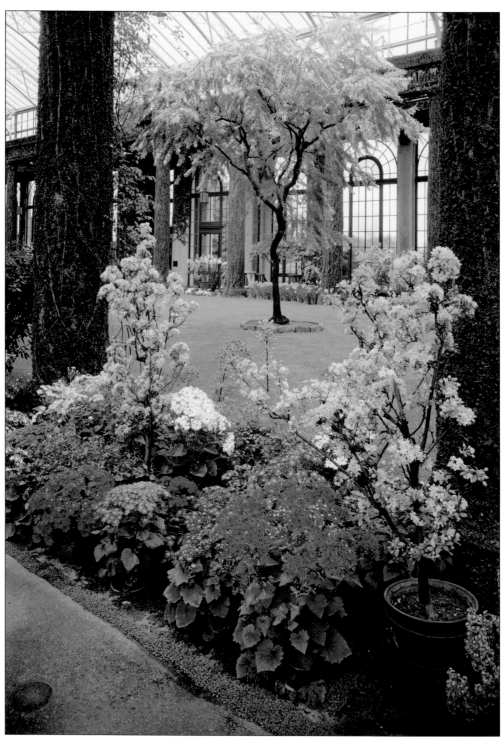

Yellow acacias were a favorite of Pierre du Pont ever since he visited the south of France in 1913 and saw them in bloom. This 1947 view shows one flowering on the west Orangery lawn, along with perennially green grass, cinerarias, and flowering crabapples. (Gottscho-Schleisner, 1947, LGA.)

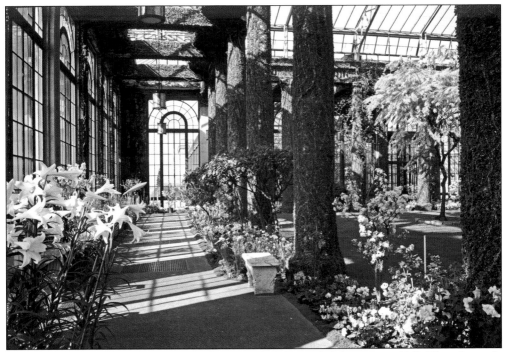

Walking in the Conservatory front door and turning left revealed this vista in 1947. The colonnade covered with creeping fig resembles giant tree trunks, with flowers grouped on either side of the walkways. Originally, citrus trees grew in this greenhouse, but they did not produce as much fruit as du Pont expected, so he concentrated on flowering plants. (Gottscho-Schleisner, 1947, LGA.)

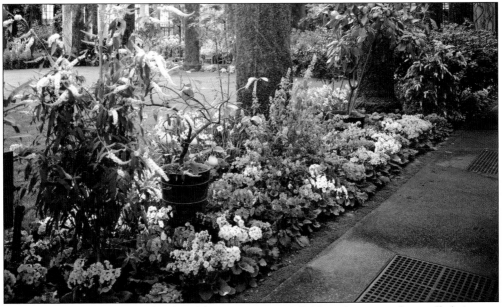

Pink primroses filled the east border of the Orangery in 1947. Note the green edging of baby's-tears, a tiny plant that Pierre du Pont first saw at Kew Gardens in London. For decades, such neat borders were hallmarks of Longwood's displays, but in recent years increased foot traffic trampled the delicate leaves, making it too difficult to use as an edging. (Gottscho-Schleisner, 1947, LGA.)

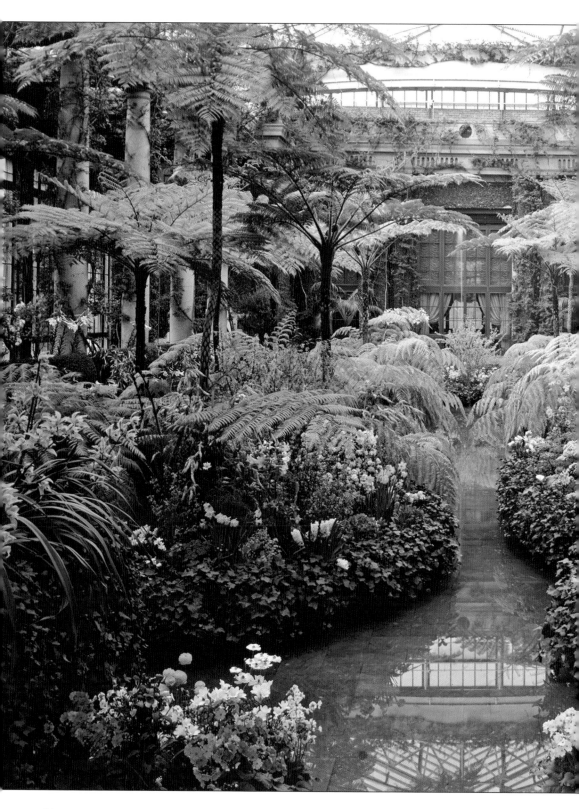

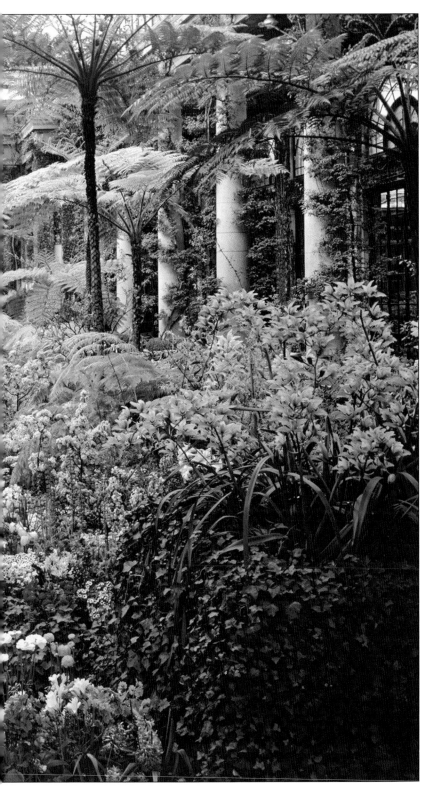

This is perhaps the quintessential view of Longwood indoors during the stewardship of Pierre du Pont. Although he had previously turned over daily operation to professional gardeners, they knew what he liked, and this 1947 view shows a breathtaking theatricality using ordinary plants grown extraordinarily well. This was doubtless assembled without a plan, just dozens of flowering potted plants moved from the growing houses into the Exhibition Hall and arranged like an English cottage garden. The result is stunning. (Gottscho-Schleisner, 1947, LGA.)

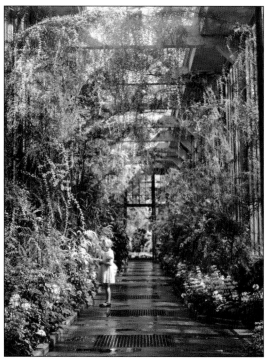

The Acacia Passage connects the Orangery to the Orchid House. Both sides are planted with *Acacia leprosa*, or cinnamon wattle, that is trained to arch over and form a leafy bower that blooms in January and early February. The fragrance is distinctive all year long, and for some, a remembrance of things past—childhood visits to Longwood. This photograph was taken in 1949. (Gottlieb Hampfler, 1949, LGA.)

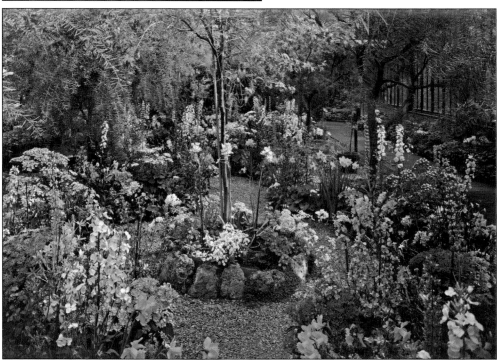

The springtime Acacia Path in 1947 was a decades-old Longwood tradition in the greenhouse between the Azalea House and the eastern Fruit Houses. A host of flowering plants bordered acacias in containers to create the type of display that might have been seen in the great New York and Philadelphia flower shows of the time. (Gottscho-Schleisner, 1947, LGA.)

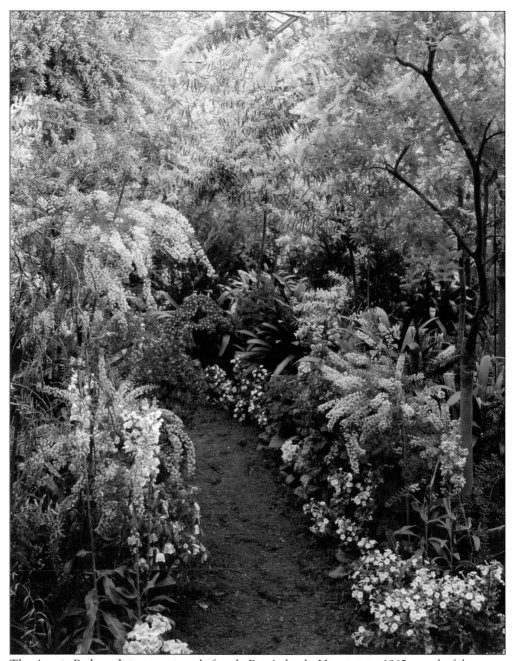

The Acacia Path tradition continued after du Pont's death. Here it is in 1965, as colorful as ever. Today, the permanent Garden Path in this area recalls the festive look of earlier springtimes but uses a variety of plants to create bloom year round. (Gottlieb Hampfler, 1965, LGA.)

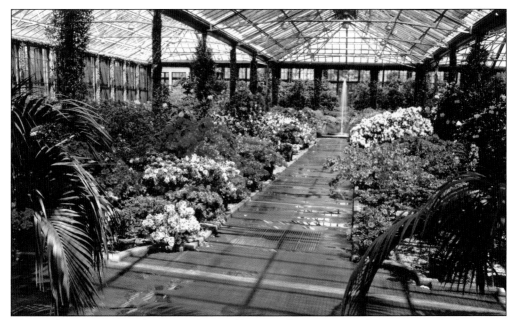

The Azalea House opened in 1928, designed by E. William Martin. This 1958 view looks east, as seen from the Exhibition Hall. Pierre du Pont's original intention was to make this a large theater, like the Exhibition Hall, with tiers for chairs, a stage, and underground dressing rooms. But he decided that a theatrical garden display of plants would be more in keeping with his horticultural goals. (Gottlieb Hampfler, 1958, LGA.)

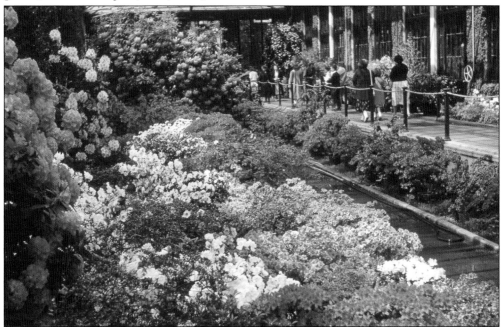

The Azalea House sheltered a tremendous collection of non-hardy azaleas and rhododendrons that bloomed in late winter and early spring with unbridled color. This 1958 view looks northwest, with the Ballroom at right. This greenhouse was replaced with the East Conservatory, built from 1969 to 1973. (Gottlieb Hampfler, 1958, LGA.)

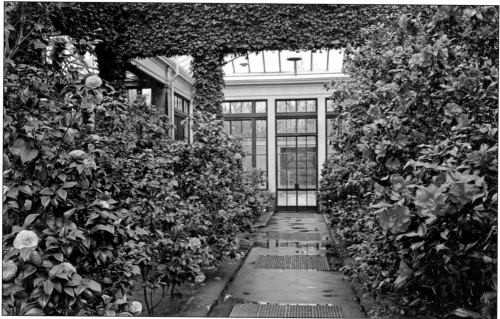

Winter-blooming camellias were a du Pont favorite, with more than 300 plants growing indoors at Longwood. Camellias were planted along the east end of the Azalea House, shown here in 1947. Cut flowers were delivered to family, friends, and employees as a special winter treat. (Gottscho-Schleisner, 1947, LGA.)

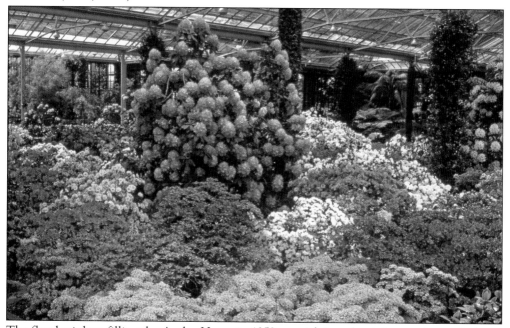

The floral rainbow filling the Azalea House in 1958 was rich in reds, pinks, purples, and whites. Pierre du Pont purchased hundreds of rhododendrons and azaleas over the years, and many grew to great size in the old Azalea House. Although some were transplanted into the new house in 1973, gradually the emphasis shifted to other types of plants with year-round interest. (Gottlieb Hampfler, 1958, LGA.)

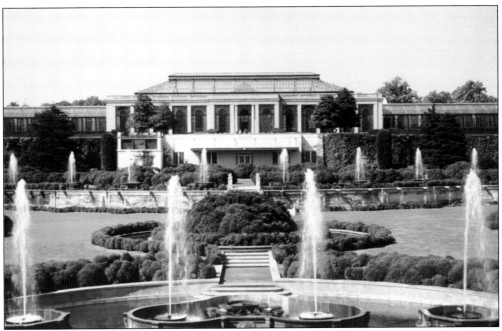

The Main Fountain Garden was the culmination of Pierre du Pont's hydraulic creations. The area was partially planted in 1921, but the fountains were not built until 1929 to 1931, with refinements added until 1938. This 1947 view shows the lower garden with two long canals, huge boxwood, and the Conservatory. (Lawrence Greeley, 1947, LGA.)

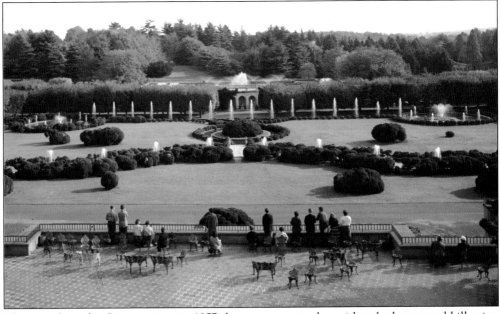

The view from the Conservatory in 1957 shows a green garden with cubed trees and billowing boxwood. The planted hillside beyond was a cornfield before 1929, when it was transformed by planting hundreds of mature trees up to 70 feet tall. A massive March snowstorm in 1958 decimated the boxwood, which never looked this luxuriant again until replanted in 2016. (Gottlieb Hampfler, 1957, LGA.)

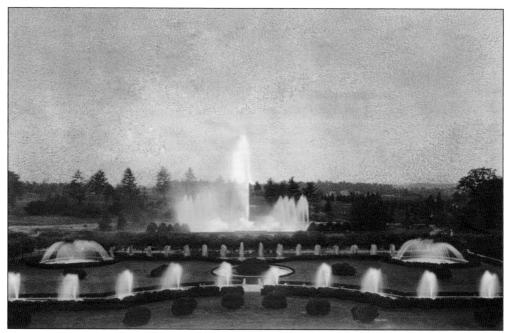

On summer evenings beginning in 1931, the fountains took on a new dimension from 724 lights with red, blue, green, yellow, and clear glass filters. This view dates from the early 1930s, when film speed was too slow to clearly capture low-light images, so a daytime photograph was hand colored to simulate an evening display. (HML.)

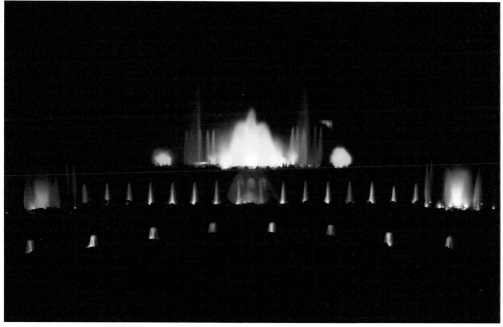

In 1957, Longwood's photographer Gottlieb Hampfler was able to capture the rainbow effect of colored lights on about 10,000 gallons of water recirculating each minute in the Main Fountains. During Pierre du Pont's time, about 475 evening displays were presented; subsequently, through 2014, about 2,750 additional shows delighted visitors. (Gottlieb Hampfler, 1957, LGA.)

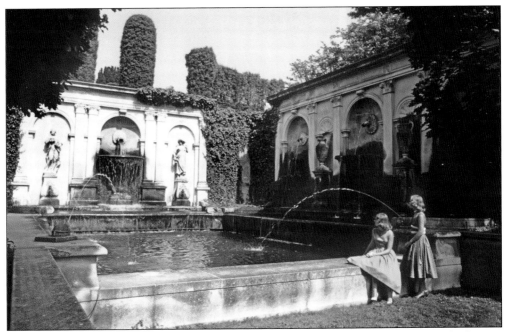

This 1950s view of the southeast corner of the Main Fountain Garden shows what is today known as the Turtle Pool, with four spouting limestone turtles as well as the only two full-figure sculptures (on the left wall) at Longwood. A large quantity of gushing water from both walls and from two weirs creates a noisy but cooling effect. (Gottlieb Hampfler, c. 1957, LGA.)

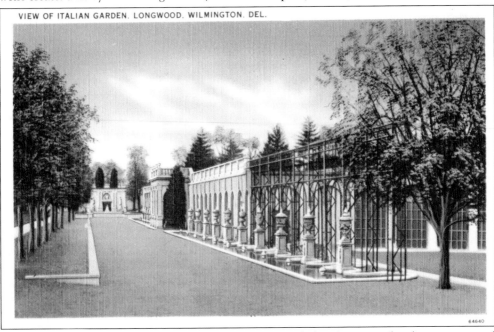

The southwest corner of the Main Fountain Garden ended with iron arches between curved "sleigh basins" surrounding vertical water jets. After this early 1930s view was photographed, the trellises were planted. In 1965, they were removed, and by 1970, the wall had been extended and a staircase constructed. (LGA.)

On the hill above the fountains, an underground reservoir supplies water to the waterfall. In this 1940s photograph, the children of employee Lawrence Greeley moved loose edging rocks to create an "old swimming hole." Du Pont was not enthusiastic about this, so it was not a frequent occurrence. (Lawrence Greeley, 1940s, LGA.)

This 1941 photograph shows the 1930 waterfall constructed by blasting away the hillside with dynamite and using the fractured rock to partially build the falls and Chimes Tower, which housed 25 tubular Deagan chimes. The bare hillside was heavily planted with mature evergreens to create Conifer Knoll. The Pear-Shaped Basin below was the reservoir for the Main Fountains until 2014, when the systems were separated. (Lawrence Greeley, 1941, LGA.)

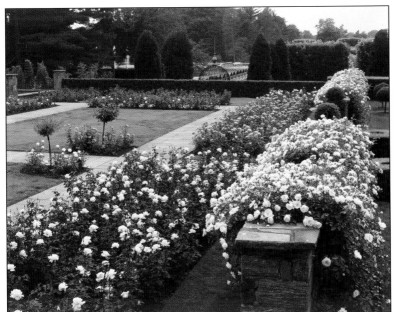

This 1960s photograph shows the Rose Garden, created in the 1930s. It was the last major garden planned by the du Ponts. 'Mrs. Pierre S. du Pont', a yellow rose bred by the famous Mallerin firm of France, was introduced in 1929 and is still available from antique rose dealers. (Gottlieb Hampfler, 1960s, LGA.)

Pierre du Pont was fascinated by sundials, so in the mid-1930s he built this unusual analemmatic dial based on one he had admired at a church in Bourg-en-Bresse in eastern France. Employees would take readings at noon every day, if sunny, so it took several years to complete. This photograph was taken in 1955. (Gottlieb Hampfler, 1955, LGA.)

Three

EDUCATING THE PUBLIC
1955–1979

Dr. Russell J. Seibert (1914–2004) was chosen as Longwood's first director in July 1955; he would serve in that capacity until 1979. Seibert was experienced in plants, farming, horticulture, agriculture, plant economics, government, and public garden administration. He was born on a farm in Belleville, Illinois, in 1914. He received degrees in geology and botany from Washington University in St. Louis, Missouri, and collected plants during the 1930s in Panama for the Missouri Botanical Garden. He established rubber plant stations in Central and South America as an agent for the US Department of Agriculture from 1940 to 1949. After a short stint as a geneticist in Beltsville, Maryland, he became the director of the Los Angeles State and County Arboretum in 1950. Five years later, he arrived at Longwood.

The trustees wanted him to "transform a private estate into an internationally recognized horticultural display." Within three months, Seibert had outlined a future for Longwood that continues to this day. Research, fellowships, plant exploration, a master plan, and horticultural designers were envisioned. The indoors needed more orchids, plant curiosities, foliage plants, bromeliads, insectivorous plants, tropicals, and medicinal plants. A better visitor route through the Conservatory would ease congestion on crowded days. The outdoors called for a greater variety of vegetables and herbs, with the best shrubs and small trees showcased for the home garden.

A plant records system, involvement with garden clubs and plant societies, tours, lectures, classes, publications, a library, first-class photography, increased parking, more benches, and picnic grounds were implemented. The public wanted plants to be labeled, so a taxonomist was hired.

A burst of construction started in 1956, not unlike Pierre du Pont's expansion in the 1920s. An information center was followed by several new or reworked greenhouses, water lily pools, new outdoor gardens, and new offices. A modern Visitor Center and huge parking lot opened in 1962, followed by the cubic Palm House in 1966. A massive, reimagined Azalea House followed in 1973. Student programs for undergraduates and graduates, professional gardeners, and internationals fulfilled du Pont's dream for a school of practical horticulture as well as newly envisioned programs for future garden educators and administrators.

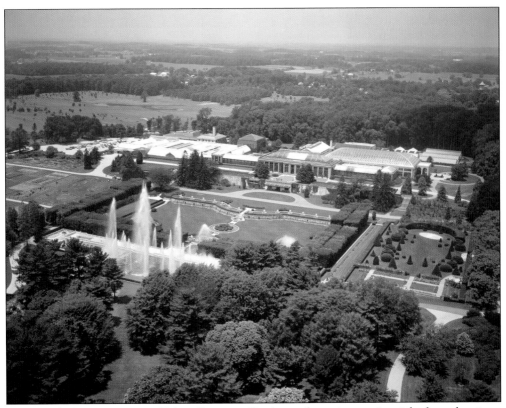

Longwood's Conservatory and Main Fountain Garden make an impressive sight from the air, as seen here in 1977. The Conservatory shelters 20 indoor gardens and covers about four acres. The Fountain Garden is another five acres, excluding the surrounding arboretum. The All-America Rose Garden and Vegetable and Herb Gardens are to the left; the du Pont Rose and Topiary Gardens are to the right. (Richard Keen, 1977, LGA.)

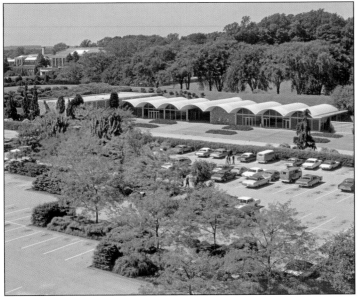

Longwood's spacious Visitor Center opened in 1962 on the site of Pierre du Pont's former golf course. The celebrated firm of Walter Dorwin Teague Associates designed the complex, which is cleverly hidden by a grassy berm on the garden side. A shop, auditorium, restrooms, and offices provided sorely needed space. The center was reconfigured in 1979 and has been enhanced several times since. (Gottlieb Hampfler, 1964, LGA.)

The All-America Rose Garden opened in 1959 just west of the Main Fountain Garden. The plants grew in curving beds and contained only hybrids chosen by All-America Roses Inc. Eventually there were more than 50 varieties and 1,400 plants, with annuals, perennials, vegetables, herbs, and fruit trees nearby in what was named the Idea Garden. Beginning in 1981, the entire area was gradually redesigned. (Gottlieb Hampfler, 1967, LGA.)

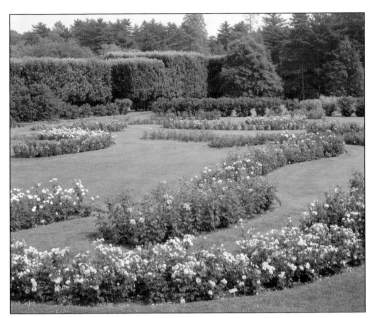

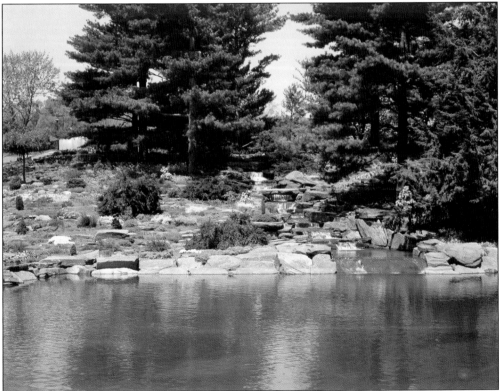

The Rock Garden was designed and constructed by gardener Karl Grieshaber and staff in 1960 around a 1930 water flume cascading down from a Main Fountain Garden basin. Some felt it was not a true rock garden, so it was renamed the Hillside Garden in 1982 and redesigned in 2005–2006 and again in 2017. Each incarnation has significantly changed its design philosophy. (Gottlieb Hampfler, 1962, LGA.)

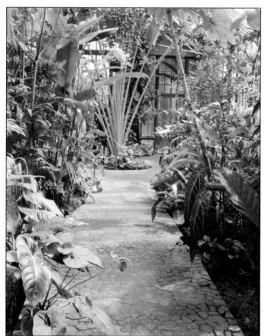

Many of the du Pont-era greenhouses were devoted to food production, and after 1955, these were gradually converted to plant display houses. Pierre du Pont preferred temperate houses because they required less heat, but the new director, Russell Seibert, was very interested in tropical botany and felt that Longwood needed tropicals indoors. A peach house was converted to this Geographic House in 1958. In 1989, this became the Silver Garden. (Gottlieb Hampfler, 1958, LGA.)

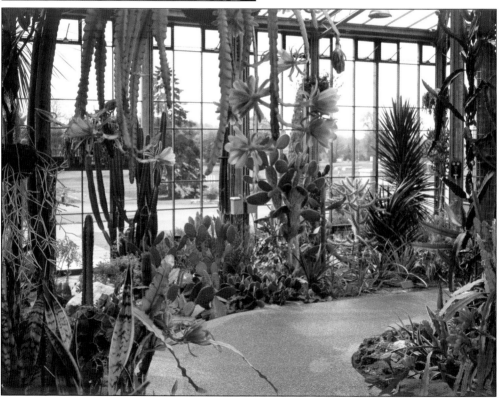

In 1957, this Desert House was constructed at the far west end of the Conservatory to display cacti and succulents but also to eliminate several bottlenecks in the visitor circulation route. In 1992, this area reopened as the Cascade Garden. (Gottlieb Hampfler, 1960, LGA.)

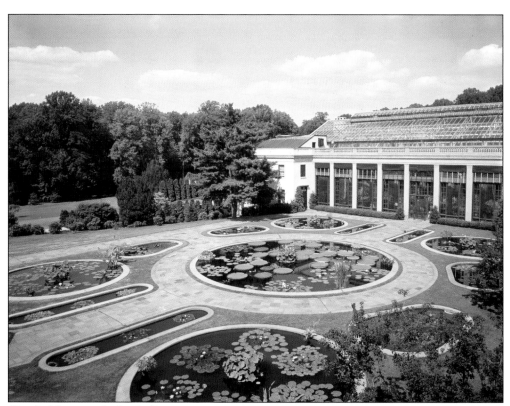

Claude Monet took the du Ponts on a tour around his Giverny water garden in 1925, but it was not until 1957 that Longwood's 13 pools opened to great acclaim. The aquatic display is famous for the enormous Longwood Hybrid water platters that grow in the center pool. (Gottlieb Hampfler, 1963, LGA.)

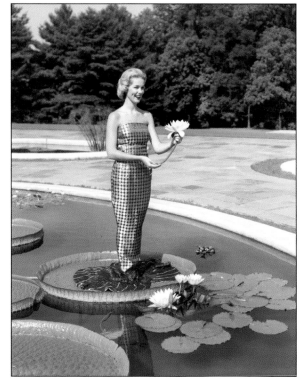

Longwood photographer Gottlieb Hampfler was not reluctant to create a memorable photo opportunity, as he did here in 1957 with a mermaid on a hybrid water platter leaf. Leaves can grow seven feet wide, weigh 10 pounds, and support up to 150 pounds. (Gottlieb Hampfler, 1957, LGA.)

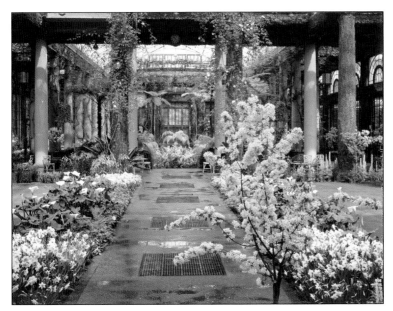

This 1964 image of the Orangery center walk in spring is one of Gottlieb Hampfler's signature photographs. He loved to move container plants, such as the flowering crabapple, into view, and he always preferred to wet down the concrete walks to darken them. (Gottlieb Hampfler, 1964, LGA.)

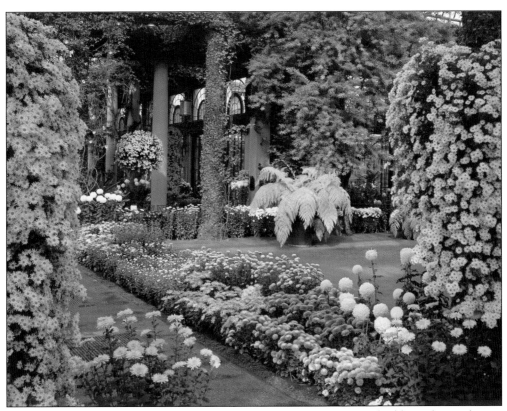

Longwood's November chrysanthemum display is justly famous. Mums had been featured since Pierre du Pont's time, but in the late 1950s, Longwood perfected techniques for growing even better cascades, hanging globes, and giant blooms on single stems. New varieties were also imported from Japan. (Gottlieb Hampfler, 1960s, LGA.)

In the 1960s, horticulture head Everitt Miller delighted in creating fanciful floral displays that celebrated the season, in this case for Easter 1960 using white lilies. He loved to relate how visitors were overwhelmed by the effect and would visibly weep. The holidays always bring huge crowds to Longwood. (Gottlieb Hampfler, 1960, LGA.)

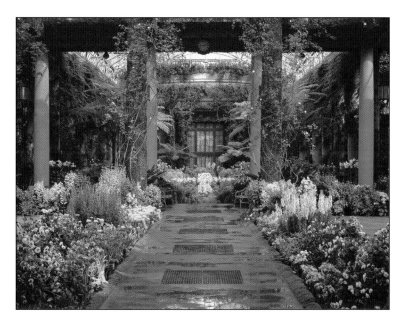

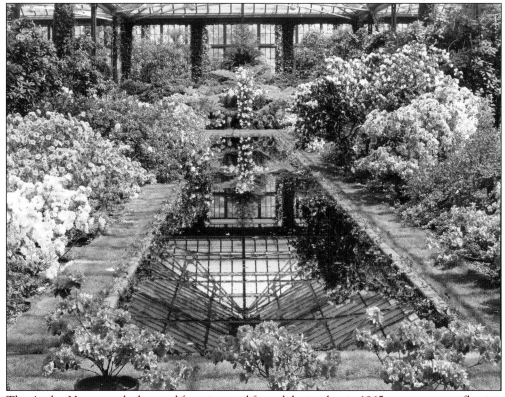

The Azalea House rarely diverged from its usual formal design, but in 1965, a temporary reflecting pool was installed down the center for Easter. Over the years, a variety of temporary exhibits have enlivened many different greenhouses for special festivals and holiday displays. (Gottlieb Hampfler, 1965, LGA.)

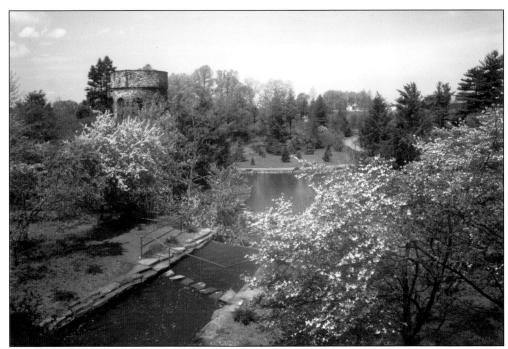

This 1958 view from the upper waterfall towards the Chimes Tower, stepping stones, and pink dogwood imparts an unusual feeling of perception with the shore of the Pear-Shaped Basin appearing a great distance away. The stepping stones have since been replaced by a sturdy bridge. (Gottlieb Hampfler, 1958, LGA.)

Educational programs have been one of Longwood's greatest contributions to horticulture. This 1957 pruning demonstration took place along former Doe Run Road, which for many years had been Pierre du Pont's private drive into Longwood. By 1962, the road was incorporated into the new Visitor Center parking lot. (Gottlieb Hampfler, 1957, LGA.)

In keeping with Pierre du Pont's tradition of hosting local charity events, the Kennett Auxiliary No. 1 was permitted to hold a fashion show and card party on May 5, 1960, with models wearing the latest spring line. That tradition continues today, with many organizations holding events at Longwood. (Gottlieb Hampfler, 1960, LGA.)

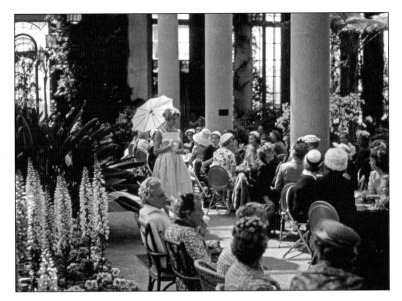

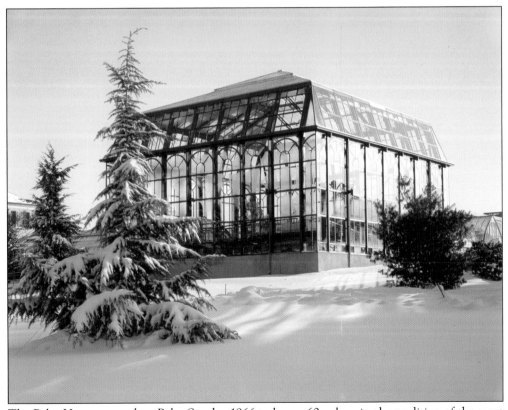

The Palm House opened on Palm Sunday 1966 to house 60 palms, in the tradition of the great European botanical gardens. The building features an elevated walkway around the inside perimeter for viewing the plants. It was designed by Victorine and Samuel Homsey Inc. from Wilmington, Delaware. Today, more than 75 different types of tropical plants flourish here, some hugging the ground and others stretching skyward. (Gottlieb Hampfler, 1966, LGA.)

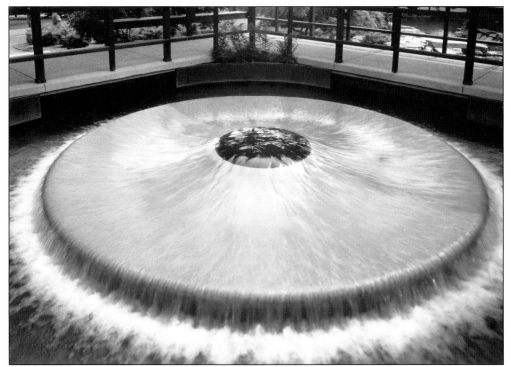

The Eye of Water debuted in 1968 on the hill behind the Main Fountain Garden. Inspired by the Ojo de Aqua atop a spring in Costa Rica, it erupts with about 4,000 gallons of pumped water per minute in a smooth laminar flow to feed the waterfall a short distance downstream. (Gottlieb Hampfler, 1970, LGA.)

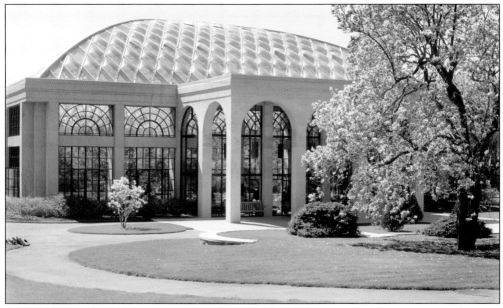

In 1973, the new Azalea House opened on the site of the 1928 structure of the same name, this time with a dramatic free-span lamella-arch roof with hundreds of diamond-shaped glazing panels. The building was subsequently renamed the East Conservatory. (Gottlieb Hampfler, 1974, LGA.)

The inaugural display in the new Azalea House (now East Conservatory) in 1973 featured red and white azaleas and yellow and white cymbidium orchids. In the foreground is an *Encephalartos woodii*, a cycad from South Africa that is one of the rarest plants in the world. It still grows today but is much larger and in a different location. (Gottlieb Hampfler, 1973, LGA.)

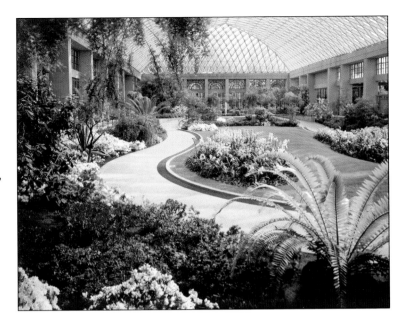

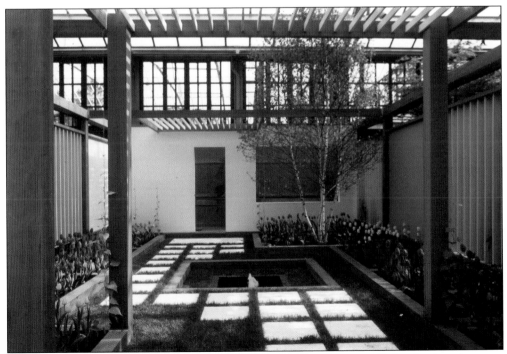

Multiple Example Gardens adjoining the East Conservatory were installed eight times between 1973 and 1985 to show indoors what home gardeners might achieve outdoors. This compact 1973 garden was designed by Philadelphia landscape architect Conrad Hamerman, who later worked on the 1992 Cascade Garden. (Gottlieb Hampfler, 1973, LGA.)

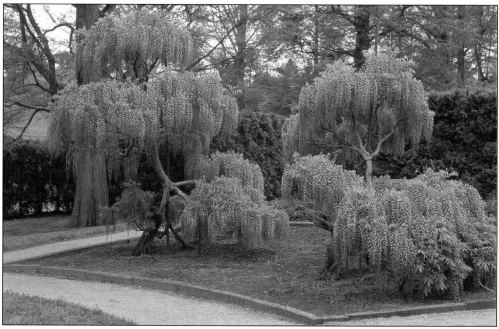

The celebrated California landscape architect Thomas Church designed the Wisteria Garden, which opened in 1976 to replace Pierre du Pont's 1908 Rose Garden. The idea came from board president William Frederick, who remembered the spectacular wisteria grown by Ethel du Pont, wife of Pierre's brother William K. du Pont. (Larry Albee, 2003, LGA.)

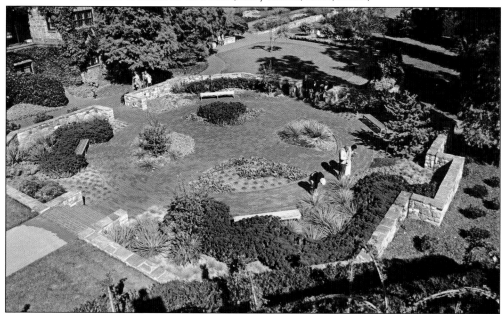

In 1975, the former Terrace Garden (shown on pages 22 and 23) was transformed by Thomas Church into the completely new Theatre Garden, shown here in 1981. This area is now a drought-tolerant landscape for all seasons, a decorative patchwork of muted colors and extravagant textures of Mediterranean inspiration. The name is derived from its proximity to the Open Air Theatre. (Dave Thomas, 1981, LGA.)

Four

SHOWMANSHIP
1979–1984

In August 1979, Russell Seibert retired after 24 years. He was succeeded by Everitt Miller (1918–2002, director 1979–1984), a commercial landscaper and retail florist who had managed the William Coe estate Planting Fields on Long Island before coming to Longwood in 1956 as chief horticulturist. In 1959, he became head of the Horticulture Department and was named assistant director in 1963. Miller was an enthusiastic public relations practitioner whose greatest achievement as director was building Longwood's restaurant.

The idea of offering refreshments dated to 1927 when Pierre du Pont contemplated a dairy bar to sell products from Longwood Farms. The thought arose again in the late 1950s, but it was not until 1979 that serious discussion began. The Terrace Restaurant opened in 1983 with both full and self-service dining just a few hundred feet east of the Conservatory. The occasion was celebrated with a lavish garden party, the first since 1940.

A new focus on visitor education used fresh publications, better signs, and reinvigorated tours. The outdoor Idea Garden was reworked beginning in 1981 to increase Longwood's relevance to the average visitor with the latest in annuals, perennials, ground covers, grasses, roses, vines, herbs, berries, tree fruits, and vegetables.

Music was added to the fountains in 1980. Fireworks were first tried on Flag Day, June 14, 1980, to an audience of 3,000; these became so popular that pre-ticketing was necessary by 1985. In November 1981, the mum show became a month-long Chrysanthemum Festival built around an Asian theme, with crafts, exhibits, and performances.

But nothing compared to the growth of Longwood's Christmas display. In 1962, the display included 1,000 poinsettias indoors and a Christmas Tree Lane in the new parking lot for six days with the lighting of three evergreens for two hours each night. By 1984, there were 81 trees outdoors with 60,000 lights, but safety concerns from so many cars prompted Longwood in 1985 to move the outdoor lighting from the parking lot into the gardens proper. Christmas has grown steadily, with more than 400,000 visitors in recent years enjoying an extravaganza of 500,000 lights, concerts, dancing fountains, and superb floral displays.

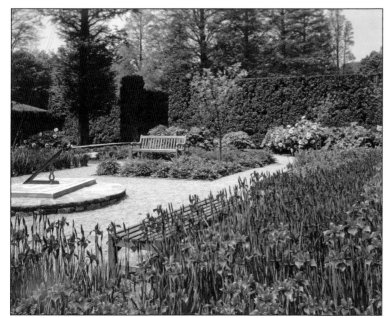

In 1976, Pierre du Pont's 1908 boxwood Sundial Garden reopened as the Peony Garden, designed by Thomas Church. It was filled with May-blooming tree peonies and regal Siberian irises in a rigid design. In 2017, it was replanted with herbaceous peonies and other plants to create a three-season abstract tapestry of colorful bloom, from spring through fall. (Larry Albee, 1984, LGA.)

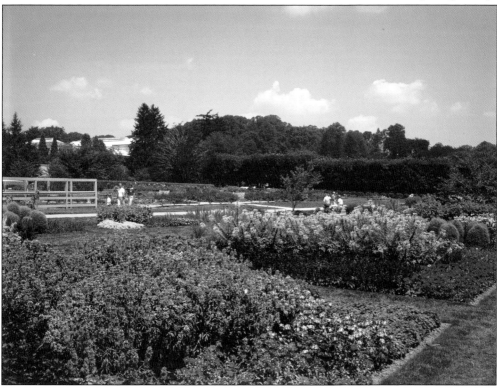

In 1981, the Idea Garden southwest of the Conservatory was redesigned to be more useful to home gardeners, with a wealth of annuals, perennials, vegetables, herbs, small tree and bush fruits, textured and shade-loving plants, raised beds for easy maintenance, containers of all types, and virtually anything else the amateur gardener could crave. It is pictured in 1984 at the peak of summer bloom. (Larry Albee, 1984, LGA.)

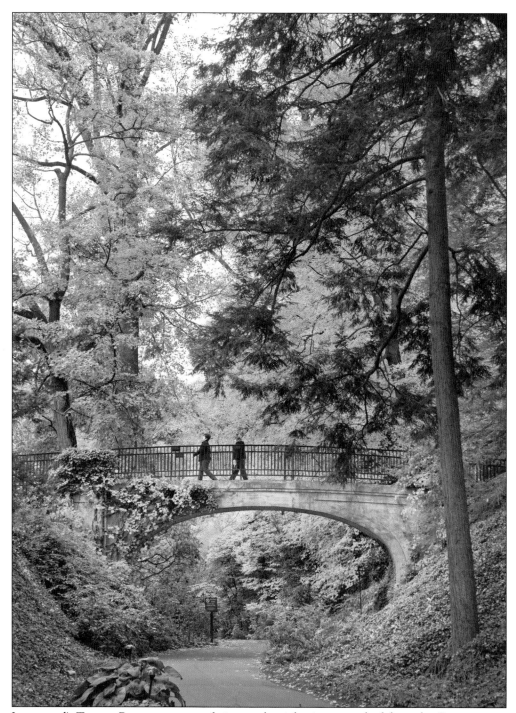

Longwood's Terrace Restaurant, out of view to the right, is approached from the Conservatory across a charming bridge built in 1923. It carried a steam line to the Peirce-du Pont House, but it was said that Pierre du Pont also built it so that his wife could safely walk to the Conservatory. Doe Run Road beneath was a public thoroughfare that was relocated a few years later. (Larry Albee, 2015, LGA.)

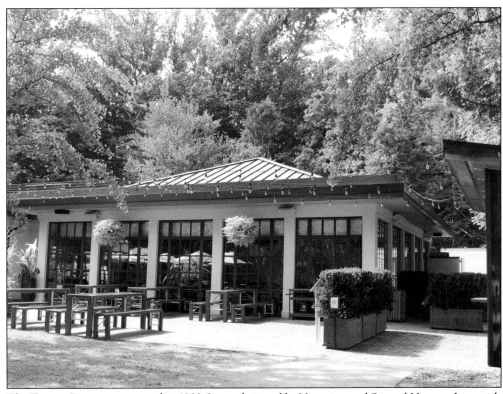

The Terrace Restaurant opened in 1983. It was designed by Victorine and Samuel Homsey Inc., with full-service sit-down dining in one room and three rooms with self-service café seating. Spacious outdoor patios are available during good weather. Ingredients sometimes come from Longwood's own vegetable garden. Guests can also enjoy special buffets and holiday feasts throughout the year. (Cathy Matos, 2015, LGA.)

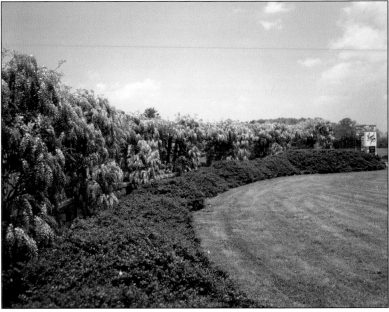

By 1979, the wisteria planted on the front entrance gates in the 1960s produced a breathtaking floral display in May. In 2010, the planting was redesigned and the wisteria was removed, but the new landscape provides greater interest overall throughout the year. (Richard Keen, 1979, LGA.)

The East Conservatory had matured into a stunning display by 1985. Three overlapping pools installed in 1977 provided picturesque reflections of the honeycombed roof, with borders of seasonal plants like these cymbidium orchids. Large holly trees provided vertical anchors, backed by feathery yellow-blooming acacias. (Larry Albee, 1985, LGA.)

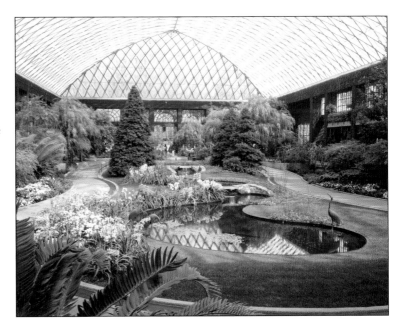

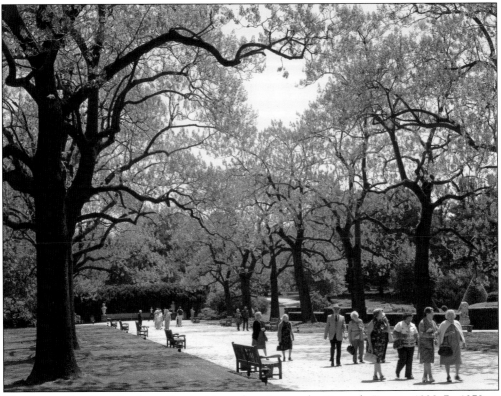

The former Doe Run Road was lined with paulownia trees by Pierre du Pont in 1938. By 1979, as shown here, the trees had matured into a magnificent avenue that bloomed in a haze of purple in May. In 2000 and 2001, the allée was replanted with propagations from these original trees. Fortunately, they grow very fast. (Richard Keen, 1979, LGA.)

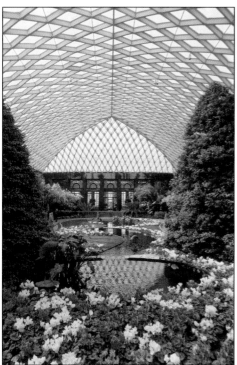

A giant Christmas tree in the Conservatory was a tradition for the du Ponts and their employees from 1921 to 1942, but it was not until 1957 that holiday flowers were first displayed in large quantities. This 1985 view of the East Conservatory at Christmas shows cyclamen in abundance. (Larry Albee, 1985, LGA.)

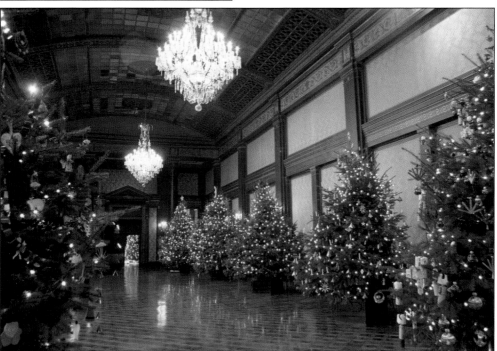

In 1979, a first-ever holiday competition was staged in the Ballroom, with six garden clubs decorating 12-foot trees to reflect different countries. Attendance soared to more than 130,000 for the first time. Today, the Christmas display attracts more than 400,000 guests. (Richard Keen, 1979, LGA.)

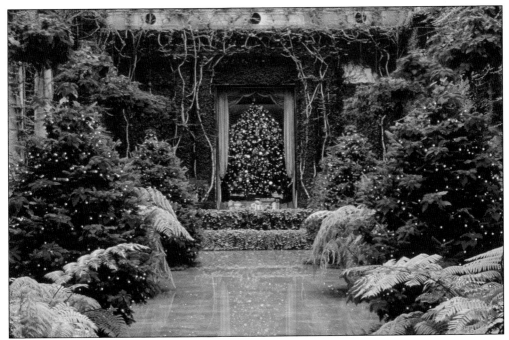

Longwood's gardeners constantly invent ingenious ways to display plants. In 1984, live trees were decorated with potted poinsettias held in place by wire armatures with a hidden spaghetti-tube watering system. Poinsettias were suspended above like baskets of rubies. (Larry Albee, 1984, LGA.)

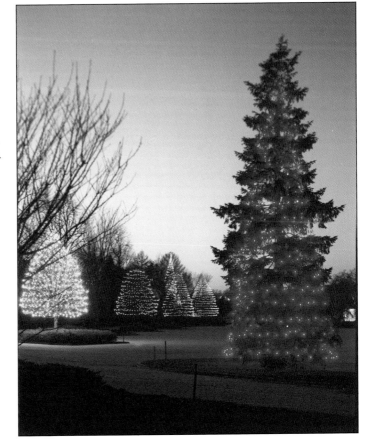

From 1962 to 1984, Longwood's parking lot was festooned with Christmas Tree Lane. By 1985, the lights had been moved inside the gardens out of concern for pedestrian safety. This photograph shows the parking lot in 1971. That year, the display featured 30,000 lights; today's total has risen to a half-million LEDs. (Gottlieb Hampfler, 1971, LGA.)

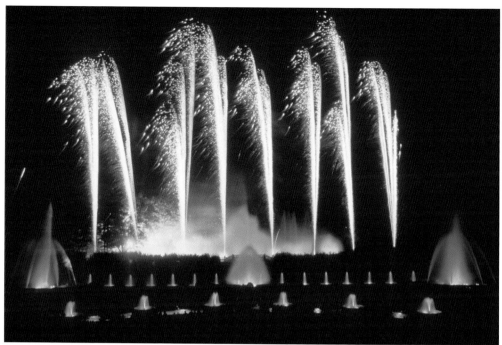

In 1980, fireworks were first tried with a musical fountain display. Firing cues were given using voice commands over walkie-talkies. By 1984, computers ran the fountains, and in 1993, when this photograph was taken, the fireworks were semiautomated. Finally, in 1998, computers ran both fountains and fireworks. (Larry Albee, 1993, LGA.)

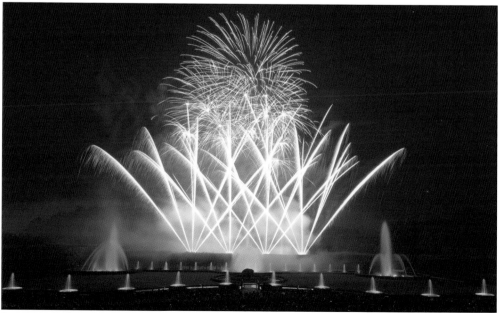

Longwood's fireworks and fountains attract capacity audiences of 5,800 ticket holders. It is one of the most artistic pyrotechnical spectacles to be found anywhere. Rather than relying on a sheer volume of fireworks, the show treats each explosion as an actor in a fountain musical. (Larry Albee, 2006, LGA.)

Five

THE ART OF THE GARDEN
1984–2006

In 1984, Frederick Roberts (b. 1942, director 1984–2006) became the new chief executive. Roberts earned a horticulture degree from the University of Connecticut and his master's degree from the Longwood Graduate Program in Public Horticulture at the University of Delaware. He had directed Kingwood Center in Mansfield, Ohio, and the Worcester County (Massachusetts) Horticultural Society before returning to lead Longwood. His strong public garden experiences were augmented by his appreciation for Longwood's early horticultural history, which was his graduate thesis topic.

The ultimate goal of the trustees was to make Longwood the world's premier horticultural display garden, and Roberts felt this could be done through improved growing practices, the latest research techniques, inspired design, and the best possible maintenance of buildings and utilities.

A new master plan was begun, and new gardens were under way. The greenhouse south of the East Conservatory that had housed changing Example Gardens from 1973 to 1985 was transformed into a permanent Garden Path, which opened in 1986. In 1987, an indoor Children's Garden opened in the former Container House.

Outdoors, the original 1957 layout of 13 water lily pools was rebuilt to open in 1989 as five brim-full pools with 30 percent more surface area.

In 1985, the staff began thinking about rebuilding some of the smaller display greenhouses to create new visitor experiences. The 1989 Silver Garden, 1992 Cascade Garden, and 1993 Mediterranean Garden were all designed by well-known landscape artists as works of art. The central Orangery and Exhibition Hall were completely rebuilt and reopened in 1996, looking as grand as when first unveiled in 1921, only now with the latest infrastructure.

Outdoors, Peirce's Woods adjoining Peirce's Park was populated with native plants to create an art-form woodland garden. Millions of spring bulbs were planted throughout the property to bring a special brightness to late winter. And the Italian Water Garden was completely rebuilt by 1992.

In the new century, a 62-bell carillon in 2001, the Estate Fruit and Bonsai Houses in 2002, and a new East Conservatory in late 2005 debuted to immense acclaim. Attendance was up, and the future of Longwood was indeed promising.

During Pierre du Pont's time, the Open Air Theatre fountains were rarely seen during the day. In 1987, computers were first used to permit short displays of both the Open Air Theatre and Main Fountains at full capacity on a daily basis. In the fall especially, the low angle of the sun creates magical rainbows during the morning shows in the theater. Shown here is the full display with the stage covers removed. (Larry Albee, 2003, LGA.)

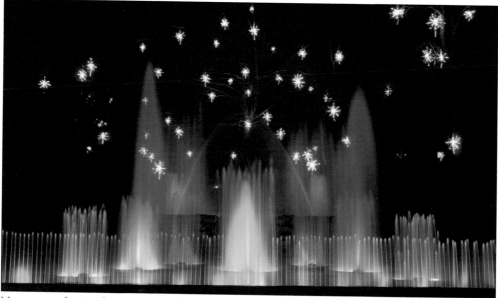

New ways of using fountains are a hallmark of Longwood. In 1987, the Open Air Theatre was first used for musical Christmas displays. The recirculating water drains into a reservoir and can operate as long as the air temperature stays above freezing. Configurations of lights in the trees behind have varied over the years. (Larry Albee, 2009, LGA.)

Fountains are one of the most vulnerable features in gardens and require extensive maintenance to keep them spouting. In 1992, the 1927 Italian Water Garden reopened after a complete two-year rebuilding that restored its original look but with new pumps, plumbing, and controls. (Larry Albee, 2009, LGA.)

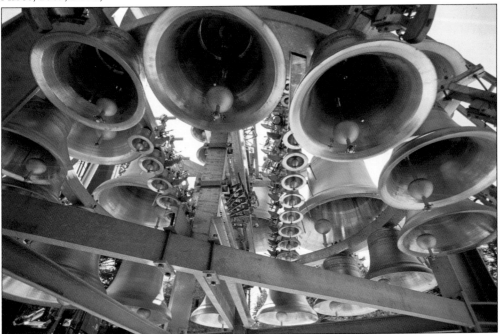

In 1930, Pierre du Pont hung 25 Deagan tubular chimes in his new Chimes Tower. These were replaced with an electronic carillon in 1956. In 2001, an Eijsbouts carillon with 62 bells crafted in the Netherlands was installed with a traditional baton keyboard played by striking the keys with the fists. The instrument also has a touch-sensitive computer system to play the bells automatically. (Larry Albee, 2001, LGA.)

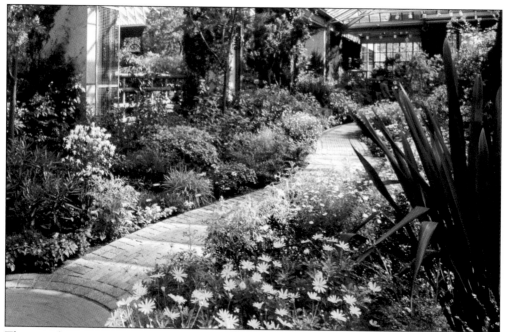

The greenhouse displaying changing Example Gardens from 1973 to 1985 was transformed into the permanent Garden Path, which opened in 1986. Reminiscent of the exuberant Acacia Path that bloomed here during Pierre du Pont's time, the Garden Path (shown here in 1987) is a year-round tapestry of subtropical color, texture, form, and fragrance. (Larry Albee, 1987, LGA.)

In 1987, an indoor Children's Garden opened in the former Container House next to the Garden Path. Its tiny maze and interactive fountains were instantly adored by children of all ages. It was redesigned in 1990 as shown here and again more than 15 years later, reopening in 2007. (Larry Albee, 1996, LGA.)

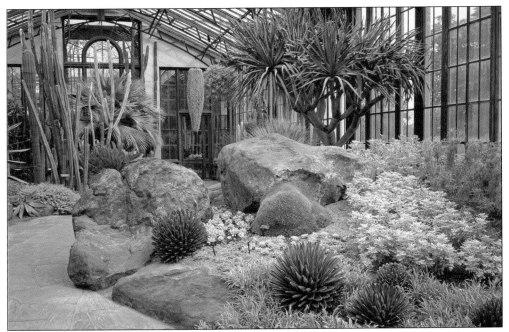

California designer Isabelle Greene transformed the former Geographic House into the Silver Garden, which opened in 1989. It recalls a desert stream bed with enormous boulders and a river of slate. Its 150 types of plants total several thousand blue, gray, and silver specimens. It is a garden experience in the purest sense, a play of light and shade, structure and form—a work of art. (Larry Albee, 2006, LGA.)

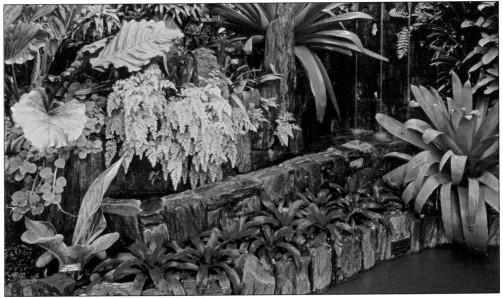

The former Desert House became the Cascade Garden with 16 waterfalls in 1992. Designed by the world-famous artist Roberto Burle Marx, who was assisted by Conrad Hamerman, it is an artistic expression of elements found naturally in the tropics of South America. It is richly planted with 150 different types of plants, many of which cling to 35 tons of Pennsylvania mica. (Larry Albee, c. 1993, LGA.)

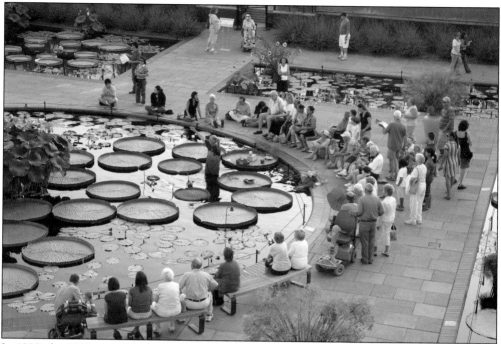

In 1989, the 1957 water lily display of 13 pools was rebuilt as five brim-full pools with 30 percent more surface area. These contain more than 100 types of day and night-blooming tropical water lilies, hardy water lilies, lotuses, giant water platters, and other aquatic and bog plants. Sir Peter Shepheard was the designer. (Larry Albee, 2008, LGA.)

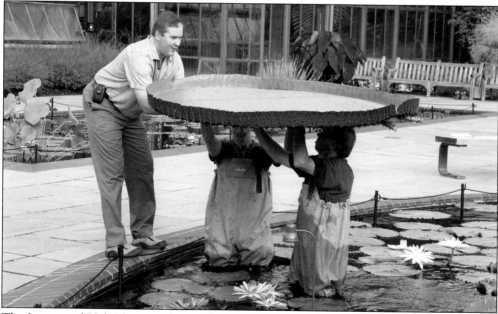

The Longwood Hybrid water platters fascinate visitors during the summer because of their enormous size. The record at Longwood for one leaf was 88 inches in diameter in 1979. Despite vicious spines on the bottom side, Longwood staff carefully remove one reinforced leaf that was subsequently reproduced as sculpture. (Larry Albee, 2008, LGA.)

The oldest greenhouse in the Conservatory (shown on page 38) was transformed in 1993 by California designer Ron Lutsko Jr. into the 100-foot-long Mediterranean Garden, celebrating some 90 different types of plants from Mediterranean-like regions of the world. The formal design is countered with chaparral-like plantings that are loose yet unusually luxuriant in the pampered conditions of Longwood's greenhouse. (Larry Albee, 2013, LGA.)

A river of white foamflower and purple phlox flows through Peirce's Woods, designed by W. Gary Smith and planted by 1995. Ferns, hollies, dogwoods, rhododendrons, and redbuds grow in abundance with emphasis on fragrant native azaleas blooming from early spring to summer. The concept of using native plants to create a woodland garden as an art form was new to Longwood. (Larry Albee, 2013, LGA.)

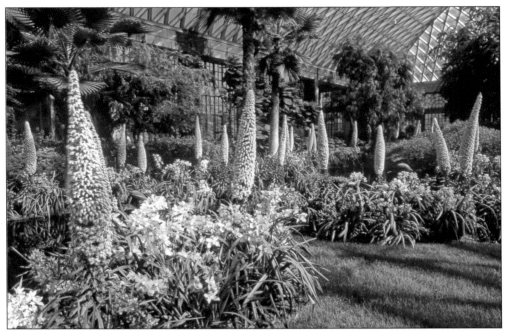

The honeycombed East Conservatory opened in 1973 and by 1998, when this photograph was taken, had matured into a spectacular garden with palm trees and space to showcase such plants as pastel cymbidium orchids and spiky echiums. But a leaky roof and poor ventilation prompted a building redesign that took 20 years to finalize and then execute. (Larry Albee, 1998, LGA.)

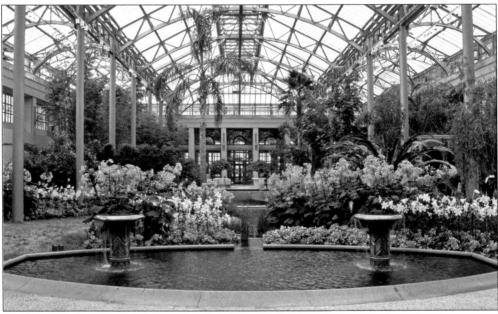

In late 2005, the redesigned East Conservatory opened under a 52-foot-high roof with a series of garden spaces recalling Moorish, French, and Modernist influences. Mediterranean and subtropical flora complement seasonal blooming plants. Water adds motion, reflection, and sound. The Court of Palms, Patio of Oranges, and Court of Bamboo provide places to linger. The interior was designed by staff member Tres Fromme, assisted by coworkers. (Larry Albee, 2006, LGA.)

Six

NEW DIRECTIONS

2006–PRESENT

On July 17, 2006, Paul B. Redman (b. 1966) became Longwood's fourth chief executive officer. Redman was born in Texas and raised on an Oklahoma ranch. He received degrees in horticulture from Oklahoma State University and worked at Hawaii's National Tropical Botanical Garden before moving to the Franklin Park Conservatory in Columbus, Ohio, as horticulture director in 1995 and, ultimately, as executive director in 1997.

Longwood's change in leadership was followed by a new focus on decentralized empowerment, marked by periodic town hall–type meetings where the entire staff partakes of the same overviews given to the board of trustees. The board was asked to take a more expansive role, particularly in visionary master planning. The planning process resulted in new mission, vision, and core value statements, along with evolving short-term strategic plans and a 40-year master plan. A plant collections policy was formalized in 2011 with important core groups such as orchids and water lilies.

Nature's Castles, three "temporary" tree houses, became much-loved enduring additions. A new indoor Children's Garden, East Conservatory Plaza, vertically planted green wall, and energy-producing solar field expanded Longwood's offerings and efficiency. The relocation of a busy public road allowed consolidation of two divided halves of the property into a wildly popular 86-acre Meadow Garden, which added a whole new dimension to a visit. The structured formality of the older gardens was, in turn, reenergized by a $90 million revitalization of the Main Fountain Garden using all the latest hydraulic, lighting, and control technology to produce an unimaginably colorful spectacle that debuted in 2017.

The performing arts have flourished as well, with world-renowned musicians from the classical, jazz, pop, and world sectors appearing, including several performances by the Philadelphia Orchestra. Longwood's 10,010-pipe organ was completely rebuilt, and a periodic International Organ Competition focused new attention on young musical talent of that genre.

Perhaps the most amazing development has been the use of the internet and social media to communicate with thousands of confirmed supporters and millions of potential guests. The latest offerings, and visitor opinions, are immediately accessible to keep Longwood Gardens in the minds of travelers and garden lovers everywhere.

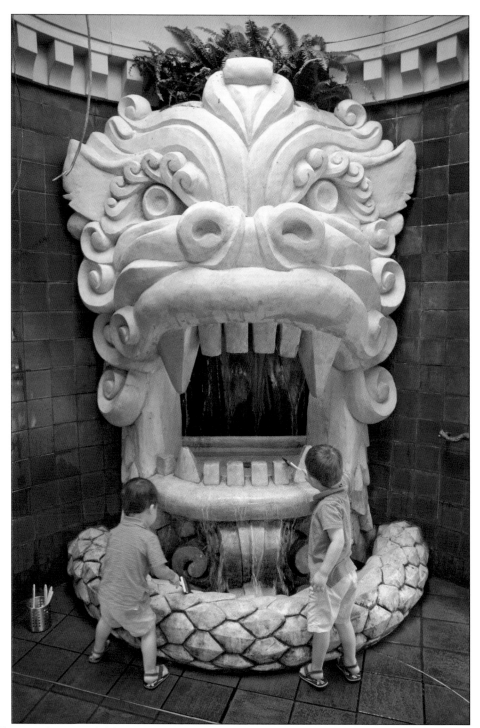

The remade 2007 Children's Garden features a secret room with a drooling dragon. Nearby is an inclined water chain and glowworm fountain, a tower with Lilliputian spiral stairs, a cave with a fog pool, and a bamboo jungle with bird fountains. No wonder it is the favorite place for young visitors! The garden was designed by Tres Fromme. (Larry Albee, 2011, LGA.)

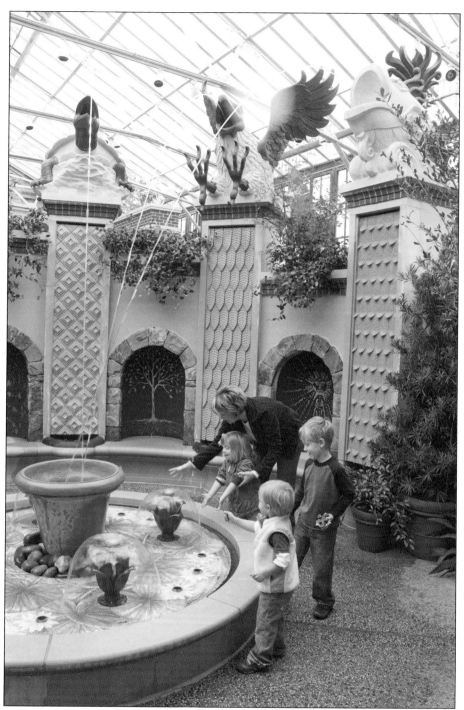

A choice spot for kids in the Children's Garden is the Central Cove with a jewel-like mosaic pool of flower-shaped water jets that pop up and down to test young reflexes. Not surprisingly, some kids are soaked by the time their parents drag them away. Additional splash comes from three glass-like laminar streams of water shooting from overhead. Towels are available to help dry off. (Larry Albee, 2007, LGA.)

Longwood's skilled horticulturists grew a chrysanthemum with 190 blooms in 2006, a total of 718 blooms in 2009, and 1,416 blooms on one plant in 2013. In 2016, the total reached 1,523! The largest examples in the Western Hemisphere of this Asian tradition attract thousands of visitors in October and November during the annual Chrysanthemum Festival. (Judy Czeiner, 2013, LGA.)

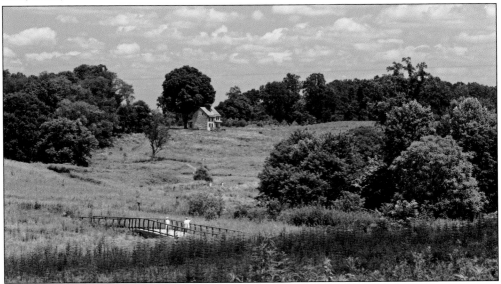

An 86-acre meadow formerly divided by a now-relocated road was redesigned by Jonathan Alderson and reopened in 2014 to add a new dimension to Longwood's displays. Mowed paths, elevated walkways, wooden shelters, and pleasing bridges permit visitors to make their way on foot to a distant 1730 farmhouse, now an interpretive center. The public's enthusiastic response has exceeded expectations. (Larry Albee, 2015, LGA.)

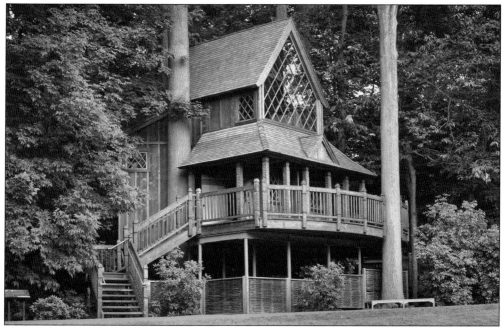

Nature's Castles, three unique tree houses scattered around the eastern half of the gardens, opened in 2008 as a temporary attraction, but the response was so enthusiastic that the structures have remained. The Canopy Cathedral shown here was inspired by a Norwegian church. The other tree houses are named the Birdhouse and the Lookout Loft. (Ashby Leavell, 2011, LGA.)

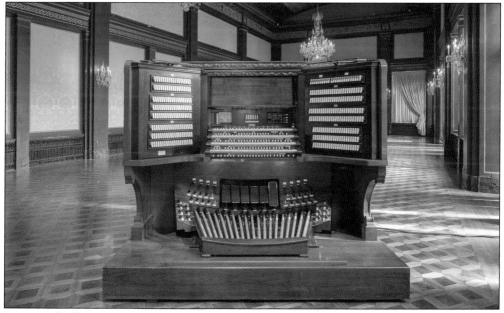

Longwood's 55-ton Aeolian organ is justly famous, with 10,010 pipes up to 32 feet long that fill the Ballroom with glorious music almost every day. The organ was built from 1929 to 1930 and rebuilt from 1957 to 1959 and again from 2004 to 2013. This console dates from 2001 and has computer controls, although the pipes (hidden behind the fabric wall on the left) have been restored to their 1930 sound. (Len Levasseur, 2015, LGA.)

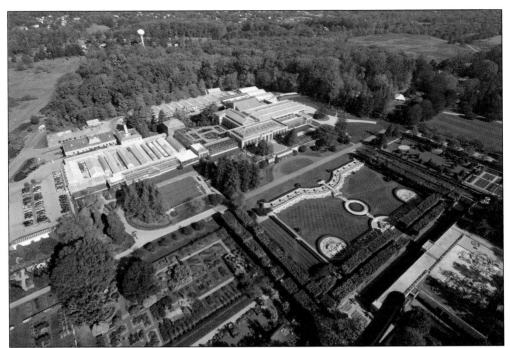

Compared to the 1977 aerial view on page 56, this 2011 view reveals a few changes, mostly in the Idea Garden, left of the Main Fountain Garden. Longwood's heritage of trees is always obvious, especially in the woods backing up to the Conservatory. Their naturalness contrasts with the formality of the Main Fountain and Topiary Gardens. (State Aerial Farm Statistics Inc., 2011, LGA.)

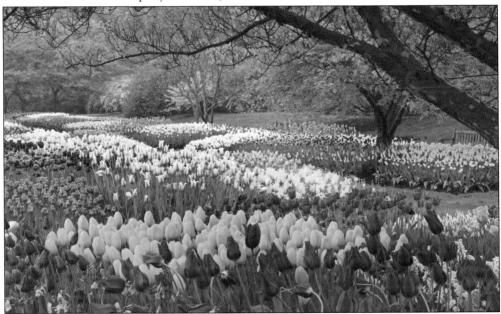

The Idea Garden showcases a rainbow of tulips every spring from mid-April to early May. The design varies every year and makes for countless photo opportunities. An equally lavish but more linear display unfolds along the 600-foot-long Flower Garden Walk, where tulips are mixed with other types of flowers. In all, nearly a quarter million tulips dazzle visitors. (Larry Albee, 2008, LGA.)

The Trial Garden opened within the Idea Garden in 2013. It showcases an abundance of cultivated plant varieties and teaches visitors about the gardening techniques used here. This photograph shows the 2015 trial where any Longwood gardener could select three to eight annuals from 160 possibilities to design combination beds, 26 in all. Each bed had a theme name. Guests could vote for their favorites. (Tyler Altenburger, 2015, LGA.)

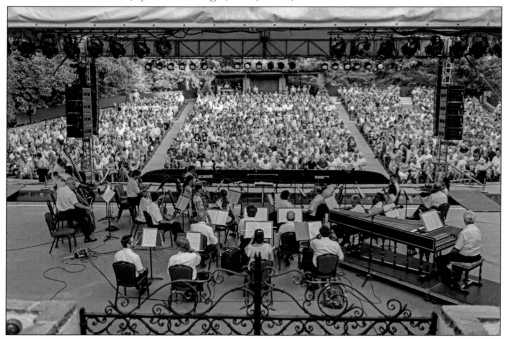

The Philadelphia Orchestra first performed at Longwood in 1941 under the baton of Eugene Ormandy. Their next visit was not until 2008, but they have returned several times to thrill music lovers in various locations throughout the gardens. Here they are in 2016 in the Open Air Theatre as a baroque ensemble performing Handel, Mozart, and Vivaldi. (Laurie Carrozzino, 2016, LGA.)

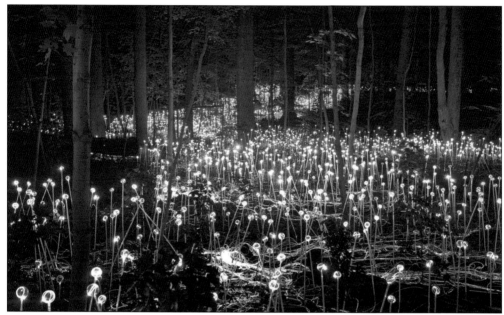

During the summer of 2012, Longwood presented *Light: Installations by Bruce Munro*, which filled the gardens with eight large-scale, site-specific installations, many using fiber optics. The Forest Walk overflowed with *Forest of Light*, 20,000 illuminated spheres lining the paths. Munro was inspired by the way dormant seeds burst into life after a rainfall. Visitors were astounded. (Larry Albee, 2012, LGA.)

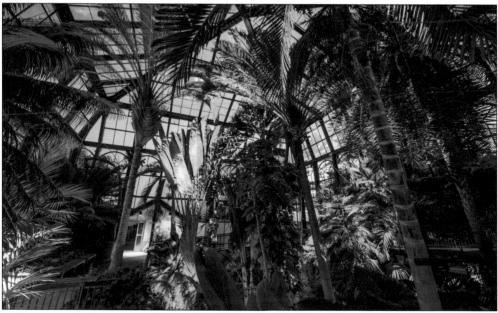

Nightscape: A Light and Sound Experience by Klip Collective was a blockbuster exhibit during the summer and fall of 2015 and 2016. Site-specific installations projected colorful abstract videos onto plants. The Palm House, shown here, became a living jewel set among glittering stars. Outdoors, kaleidoscopes and flying fish colored the trees. Specially composed music throughout the gardens capped a truly unique experience. (Harold Davis, 2015, LGA.)

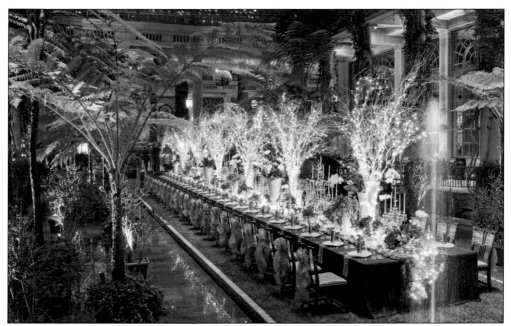

Christmas at Longwood never fails to excite. In 2012, a 64-foot-long banqueting table on a living turf carpet was set for a floral feast with 48 place settings. A moss table runner, silver, china, and begonias, orchids, dried roses, ferns, and willow branches filled the table. The fanciful creation paid tribute to the entertaining the du Ponts did at Longwood. (Larry Albee, 2012, LGA.)

In 1985, Longwood's Christmas lights were completely moved from the parking lot into the gardens. Over the years, the display has been refined and expanded with changes made every year. The effect is restrained and elegant, without a blitzkrieg of flashing. Colors are carefully coordinated, such as these alternating red and green cones built around paulownia trees. (L. Albee, 2006, LGA.)

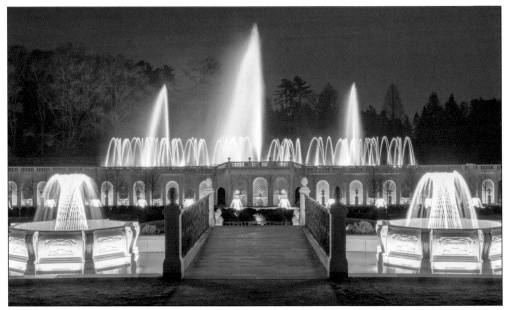

The 1931 Main Fountain Garden had reached the end of its usable life by 2014. There were massive leaks, and the stonework was crumbling. From late 2014 until the spring of 2017, the entire garden was demolished and then rebuilt in a $90 million revitalization that included 1,400 feet of new tunnels to hold the utilities. The restored stonework and new lighting make the garden come alive as never before. (Daniel Traub, 2017, LGA.)

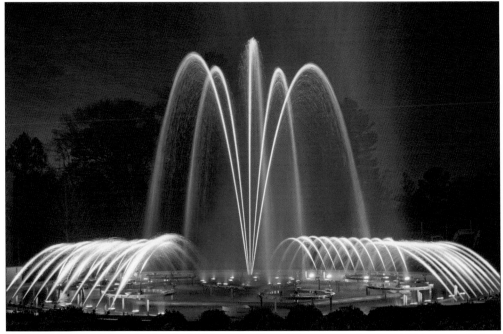

The old Main Fountain Garden had 386 water effects. The new garden has 1,719 jets, including 16 spinning and 19 robotic nozzles, 32 water cannons, and all the original legacy effects. The tallest jet rose 140 feet; now it can rise up to 175 feet. Here is the Round Basin on one end of the Lower Canal with new jets and lights. (Daniel Traub, 2016, LGA.)

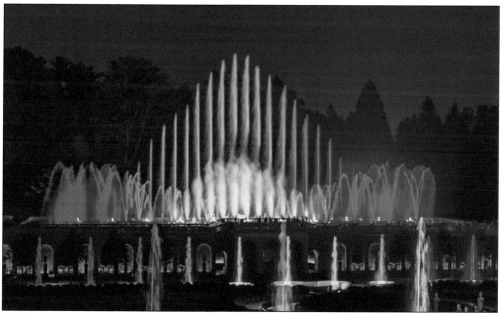

In 1931, there were 724 incandescent fountain lights with red, blue, green, yellow, and clear glass filters. The new system is all LEDs, with 1,024 fountain lamps, each filled with red, blue, green, amber, lime, and cyan diodes permitting every imaginable color. Fixtures are individually controllable, and the color saturation is extraordinary. There are also 1,700 lights for architectural lighting and smaller water features. (Richard Donham, 2017, LGA.)

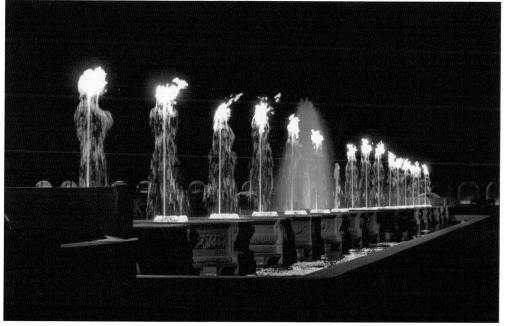

Most amazing in the new Main Fountain Garden are 30 water jets that can catch fire in the Upper and Lower Canals. Gas is injected into the fountain nozzle and ignited. The flame rises with the water, and once the igniter is turned off, the flame tops the jet like an aquatic birthday candle. Each is individually controllable. (Laurie Carrozzino, 2017, LGA.)

Gardens Map

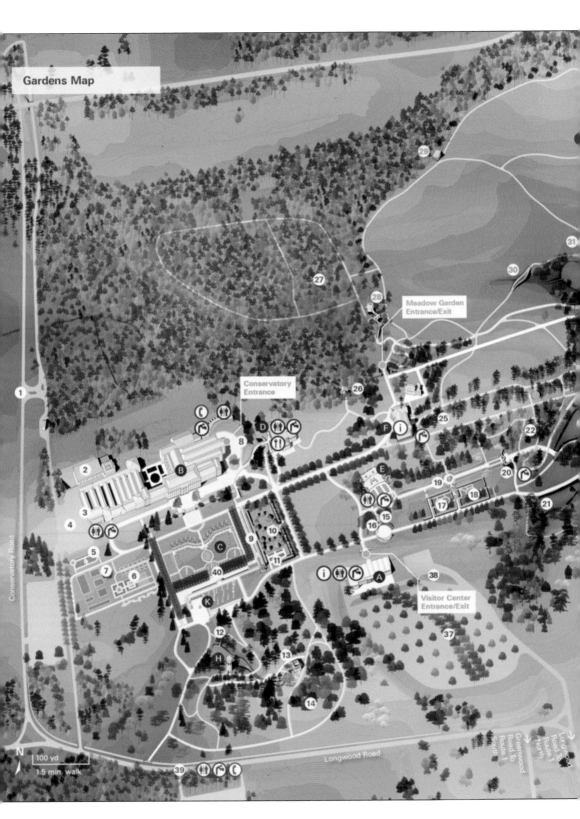

Conservatory Entrance

Meadow Garden Entrance/Exit

Visitor Center Entrance/Exit

Longwood Road

Conservatory Road

Longwood Road To Route 1 North

Greenwood Road To Route 1 South

100 yd
1.5 min. walk

N

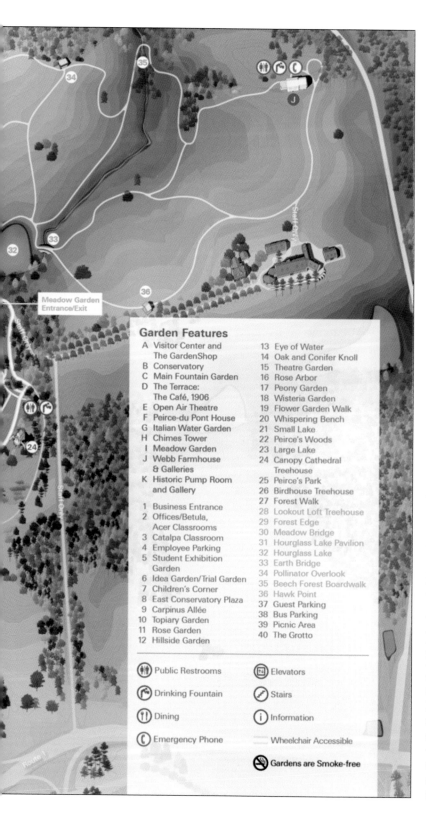

Garden Features

A Visitor Center and The GardenShop	13 Eye of Water
B Conservatory	14 Oak and Conifer Knoll
C Main Fountain Garden	15 Theatre Garden
D The Terrace: The Café, 1906	16 Rose Arbor
	17 Peony Garden
E Open Air Theatre	18 Wisteria Garden
F Peirce-du Pont House	19 Flower Garden Walk
G Italian Water Garden	20 Whispering Bench
H Chimes Tower	21 Small Lake
I Meadow Garden	22 Peirce's Woods
J Webb Farmhouse & Galleries	23 Large Lake
	24 Canopy Cathedral Treehouse
K Historic Pump Room and Gallery	25 Peirce's Park
	26 Birdhouse Treehouse
1 Business Entrance	27 Forest Walk
2 Offices/Betula, Acer Classrooms	28 Lookout Loft Treehouse
	29 Forest Edge
3 Catalpa Classroom	30 Meadow Bridge
4 Employee Parking	31 Hourglass Lake Pavilion
5 Student Exhibition Garden	32 Hourglass Lake
	33 Earth Bridge
6 Idea Garden/Trial Garden	34 Pollinator Overlook
7 Children's Corner	35 Beech Forest Boardwalk
8 East Conservatory Plaza	36 Hawk Point
9 Carpinus Allée	37 Guest Parking
10 Topiary Garden	38 Bus Parking
11 Rose Garden	39 Picnic Area
12 Hillside Garden	40 The Grotto

(♛) Public Restrooms	(▦) Elevators
(☛) Drinking Fountain	(∅) Stairs
(♜) Dining	(i) Information
(C) Emergency Phone	___ Wheelchair Accessible
	(🚭) Gardens are Smoke-free

This map of Longwood Gardens today shows the rich diversity of landscapes that await the guest. From the entrance (A), one can enjoy the oldest gardens to the right, the huge 86-acre Meadow Garden at upper right, and the Conservatory, Main Fountain Garden, and Idea Garden at left. In all, about 400 acres—of a total 1,083 acres— are accessible to the public. (LGA.)

DISCOVER THOUSANDS OF LOCAL HISTORY BOOKS FEATURING MILLIONS OF VINTAGE IMAGES

Arcadia Publishing, the leading local history publisher in the United States, is committed to making history accessible and meaningful through publishing books that celebrate and preserve the heritage of America's people and places.

Find more books like this at
www.arcadiapublishing.com

Search for your hometown history, your old stomping grounds, and even your favorite sports team.

Consistent with our mission to preserve history on a local level, this book was printed in South Carolina on American-made paper and manufactured entirely in the United States. Products carrying the accredited Forest Stewardship Council (FSC) label are printed on 100 percent FSC-certified paper.

MADE IN THE USA